Bad

Pics

Fixed

Quick

**HOW TO FIX LOUSY DIGITAL PICTURES
USING ADOBE® PHOTOSHOP® ELEMENTS 3**

que®

Bad Pics Fixed Quick: How to Fix Lousy Digital Pictures Using Adobe® Photoshop® Elements 3

International Standard Book Number: 0-7897-3209-2

Library of Congress Catalog Card Number: 2004107047

Printed in the United States of America

First Printing: October 2004

07 06 05 04 4 3 2

Trademarks

Warning and Disclaimer

Bulk Sales

Que Publishing offers excellent discounts on this book when ordered in quantity for bulk purchases or special sales. For more information, please contact

U.S. Corporate and Government Sales
1-800-382-3419
corpsales@pearsontechgroup.com

For sales outside the United States, please contact

International Sales
international@pearsoned.com

Associate Publisher
Greg Wiegand

Acquisitions Editor
Michelle Newcomb

Development Editor
Laura Norman

Managing Editor
Charlotte Clapp

Project Editor
Tonya Simpson

Production Editor
Megan Wade

Indexer
Erika Millen

Proofreader
Katie Robinson

Technical Editor
Kate Binder

Publishing Coordinator
Sharry Lee Gregory

Book Designer
Anne Jones

Page Layout
Stacey Richwine-DeRome

Contents at a Glance

I How to Use Photoshop Elements to Fix Your Pictures

II How to Fix Pictures That Are Too Big or Too Small

IV How to Fix Otherwise Perfect Pictures of Imperfect People

About the Author

Michael Miller has written more than 50 nonfiction books over the past 15 years. His books for Que include *Bargain Hunter's Guide to Online Shopping*, *Absolute Beginner's Guide to Computer Basics*, and *Absolute Beginner's Guide to eBay*. He is known for his casual, easy-to-read writing style and his ability to explain a wide variety of complex topics to an everyday audience.

You can email Mr. Miller directly at badpics@molehillgroup.com. His Web site is located at www.molehillgroup.com.

Dedication

To Alec and Ben, two very photogenic subjects.

Acknowledgments

Thanks to the usual suspects at Que, including but not limited to Greg Wiegand, Michelle Newcomb, Laura Norman, Tonya Simpson, and Megan Wade. Thanks also to the contributing photographers who graciously provided some of their mistakes for use in this book, including Logan Day, Alec Hauser, Mark Miller, Erica Sadun, LaDawn Weston, and Greg Wiegand. Thanks as well to the kind folks at the Lens View Photography Club for their assistance in locating contributing photographers, and to Stephanie Miller for contributing several of her old family photos. And, finally, thanks to the many subjects who posed for the photos in this book—you all look much better in person than you do in these pictures!

Contributing Photographers

Logan Day is a sixth-grader at Eagle Elementary in Brownsburg, Indiana. His hobbies are playing the piano, model railroading, and photography. He is a member of the Lens View Photography Club.

Alec Hauser is a student at Glenbard West High School in Glen Ellyn, Illinois. His hobbies are photography, anime, drawing, and reading. He uses a Fujifilm FinePix S3000 digital camera to take all of his pictures.

Mark Miller works in corporate management for a major national retailer. He is a casual photographer; his hobbies include golf, scuba diving, and watching sports on his widescreen TV.

Erica Sadun holds a PhD in computer science from the Georgia Institute of Technology. She has written, co-written, and contributed to almost two dozen books about technology, particularly in the areas of programming, digital video, and digital photography. An unrepentant geek, she has never met a gadget she didn't need.

LaDawn Weston is primarily a wedding photographer working out of Greenwood, Indiana. Her love of photography came from her father, who always had a camera aimed at his family. She got her first "real" camera from her parents for her high school graduation present. She has studied photography at Ricks College (now BYU Idaho) in Rexburg, Idaho, and at Indiana University–Purdue University Indianapolis. She now owns WestonHouse Photography and always has her camera aimed at her own family.

Greg Wiegand is an associate publisher of Que and a real gadget hound. His latest toy, used to take several of the pictures in this book, is a Nikon D70 digital SLR. The author approves.

We Want to Hear from You!

As the reader of this book, *you* are our most important critic and commentator. We value your opinion and want to know what we're doing right, what we could do better, what areas you'd like to see us publish in, and any other words of wisdom you're willing to pass our way.

As an associate publisher for Que Publishing, I welcome your comments. You can email or write me directly to let me know what you did or didn't like about this book—as well as what we can do to make our books better.

Please note that I cannot help you with technical problems related to the topic of this book. We do have a User Services group, however, where I will forward specific technical questions related to the book.

When you write, please be sure to include this book's title and author as well as your name, email address, and phone number. I will carefully review your comments and share them with the author and editors who worked on the book.

Email: feedback@quepublishing.com

Mail: Greg Wiegand
 Associate Publisher
 Que Publishing
 800 East 96th Street
 Indianapolis, IN 46240 USA

For more information about this book or another Que title, visit our Web site at www.quepublishing.com. Type the ISBN (excluding hyphens) or the title of a book in the Search field to find the page you're looking for.

Just because you have a nifty new digital camera doesn't mean that all your pictures will turn out perfect. It's all too easy to snap a photo that is too bright, too dark, off-center, tilted, or too far away from the subject. And your subjects won't always be perfect, either; the people you photograph will have bad hair days, facial blemishes, yellow teeth, and bad skin. No matter how good your camera is, you always end up taking your share of bad pictures.

In the old pre-digital days, a bad picture was a bad picture—there was nothing you could do about it, except throw the bad ones out. But with digital photography, things are different. When you transfer your pictures to your computer, you can use a digital editing program—such as Photoshop Elements—to work on your pictures and edit the mistakes. Don't like the color? Fix it. Don't like the background? Change it. Don't like that pimple on the subject's forehead? Remove it.

Bad pictures can now be fixed.

Of course, professional photographers have been editing digital photos for years. Talk to any pro photographer, and you'll find that he spends hours and hours at his computer every day, brushing away blemishes, correcting color, and otherwise fixing problem photos. Every pro photographer knows that while it takes just a second to snap a picture, it might take half an hour or more on the computer to make the photo look perfect, digitally.

The problem with that, obviously, is that you're not a professional photographer, and you don't want to spend all that time fixing your digital photos. You want to fix your problems, yes, but you want to do it the fast and easy way. You want a one-button solution, if it's available, or at the very least one that takes just a few minutes to do. You want a quick fix for your bad pics.

Fortunately, you don't have to learn highly technical procedures to fix most digital photo problems, nor do you have to invest in an expensive or hard-to-use professional software program, such as Adobe Photoshop CS. Nope, all you need to fix your pics is a copy of Adobe Photoshop Elements (which costs less than $100) and someone to show you the one-button solutions and easy fixes—which is what I do in this book.

Bad Pics Fixed Quick won't burden you with the long and involved techniques used by professional photographers—you neither want to spend that much time fixing your pictures, nor do you need 100% perfection. All you want is to make your bad digital photos look presentable, so that's what I'll show you. The techniques presented in this book are easy to do, don't take much time, and don't require any technical skills to speak of. Click a button here, pull down a menu there, and that's about it. You'll be surprised what you can achieve when you know the right tricks. Bad pictures really *can* be fixed quick!

Each chapter in this book addresses a specific type of problem—your photo is too dark or too light, or the color is off; that sort of common problem. You'll find an example of the problem at hand, and then I'll show you several ways to fix what's wrong. I start each chapter with the easiest solution to the problem; then I show you other approaches you can take—just in case the easy solution doesn't do the job. If the first method doesn't work, undo your changes and try the second, slightly more complex, method. If that one doesn't work, undo your changes again and try the third method. Hopefully, the one-button solution will do the trick; if not, just keep trying the various techniques until you're satisfied with the results.

Now, chances are any professional photographers reading this book won't like it; some might even look down their noses at the techniques I present here. But this book isn't written for professional photographers. It's written for you, the average consumer with a point-and-click digital camera and not much time or patience to fix what went wrong. Follow my instructions and you'll have your problem photos fixed in much less time than the pros spend, and your results will look so good, only a trained professional can tell difference!

How This Book Is Organized

Bad Pics Fixed Quick leads you step-by-step through fixing some of the most common photo problems you'll encounter. The book is organized into five major sections:

- **Part I, "How to Use Photoshop Elements to Fix Your Pictures"**—This part presents a brief overview of those features of the Elements program you'll be using to fix your bad pics.
- **Part II, "How to Fix Pictures That Are Too Big or Too Small"**—This part shows you how to shrink your pictures for the Web or enlarge them for printing, as well as how to crop them to zoom in on the most important parts.
- **Part III, "How to Fix General Picture Problems"**—This part presents easy fixes to some of the most common problems with digital photographs—tilted pictures, pictures that are too dark or too light, bad color, and pictures that are either too blurry or too grainy.
- **Part IV, "How to Fix Otherwise Perfect Pictures of Imperfect People"**—This part focuses on retouching the people in your pictures—eliminating red eye, getting rid of circles under the eyes, softening wrinkles, removing blemishes, whitening yellow teeth, getting rid of braces, taming unruly hair, and smoothing skin tone and color. You'll even learn how to make a plain face more glamorous with a 5-minute digital makeover!

- **Part V, "How to Fix *Really* Bad Pictures"**—This part tackles some of the tougher problems, including changing the color of an object, changing backgrounds, removing unwanted objects (and people!) from your photos, reducing glare and flare, and restoring scratched and faded prints. You'll even learn how to turn a really bad color photo into a good black-and-white one!

What You Need to Use This Book

To use the techniques presented in this book, you need a personal computer and a copy of the Photoshop Elements program; either the PC or Mac version is fine. This book is written for version 3.0 of the software; if you're using an older version of the program, I recommend that you upgrade to the latest version. The new features make fixing your pictures that much easier. No special technical expertise is required.

Naturally, you also need some digital photographs. Any picture taken by a digital camera will work, as will photo prints you scan into digital files with a scanner.

Conventions Used in This Book

I hope that this book is easy enough to figure out on its own, without requiring its own instruction manual. As you read through the pages, however, it helps to know precisely how I've presented specific types of information.

Menu Commands

Many of the tools and controls in Photoshop Elements are accessed via a series of pull-down menus. You use your mouse to pull down a menu and then select an option from that menu. This sort of operation is indicated like this throughout the book:

Menu Option 1 > **Menu Option 2** > **Menu Option 3**

All you have to do is follow the instructions in order, using your mouse to click each item in turn. When submenus are tacked onto the main menu, just keep clicking the selections until you come to the last one. For example, the instruction **Enhance** > **Adjust Color** > **Hue/Saturation** means to pull down the **Enhance** menu, select the **Adjust Color** option, and then select the **Hue/Saturation** option. It's easy.

Shortcut Key Combinations

Some Elements commands can be accessed directly from the computer keyboard, typically by pressing two keys at the same time. These two-key combinations are called *shortcut keys* and are shown as the key names joined with a plus sign (+).

For example, Ctrl+D indicates that you should press the D key while holding down the Ctrl key. If there are different shortcut keys, the Windows keyboard combination is shown first followed by the Mac shortcut.

Special Elements

This book also includes a few special elements that provide additional information not included in the basic text. These elements are designed to supplement the text to make your learning faster, easier, and more efficient.

TIP

A *tip* is a piece of advice—a little trick, actually—that helps you perform a task more efficiently.

NOTE

A *note* is designed to provide information that is generally useful but not specifically necessary for what you're doing at the moment. Some notes are like extended tips—interesting, but not essential.

CAUTION

A *caution* tells you to beware of a potentially tricky action or situation. Pay attention—or suffer the consequences!

Let Me Know What You Think

I always love to hear from readers. If you want to contact me, feel free to email me at badpics@molehillgroup.com. I can't promise that I'll answer every message, but I do promise that I'll read each one!

If you want to learn more about me and any new books I have cooking, check out my Molehill Group Web site at www.molehillgroup.com. This is also where you'll find any corrections or clarifications to this book, which I'll post as necessary.

HOW TO USE PHOTOSHOP ELEMENTS TO FIX YOUR PICTURES

CHAPTER 1

MAKING QUICK FIXES WITH PHOTOSHOP ELEMENTS

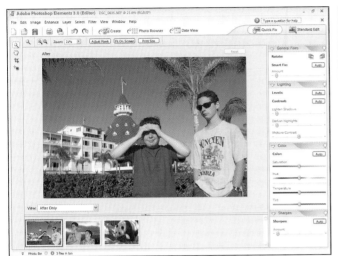

Quick Fix Mode

Standard Edit Mode

"Elements lets you make a surprising number of edits and modifications to your photos"

Let's start with the admission that you have your share of bad photos that you'd like to fix. I'll pass no judgment on that; I just admire your honesty for stepping forward and looking for a cure.

That cure, of course, comes in the form of the Adobe Photoshop Elements image-editing program. Elements lets you make a surprising number of edits and modifications to your photos, assuming you know which tools to use—and how to use them. Fortunately for you, this book is all about helping you choose the right tools and use them properly—which means we need to start with some "how to use this program" basics before we get started fixing pictures.

Select an Editing Mode

Just so we're all on the same page, so to speak, it's worth spending a few minutes to point out all the parts of the Elements screen, what they're called, and what (in general) they do. This is important even if you know how to use other computer programs because Adobe tends to have its own nomenclature for what you see onscreen; the names aren't necessarily what you think they'd be. Plus, it always helps to know where you can find what you're looking for.

In this book I'm using the latest version of the program, Photoshop Elements 3.0. This is a major update to the program, with an easier-to-use interface and some new tools that make fixing some common bad picture problems easier. If you're using an older version of the program, I strongly recommend that you upgrade to version 3.0—it's well worth the time and money.

One thing new about Elements 3.0 is that it actually includes two different programs: the Editor and the Organizer (sometimes called the Photo Browser). Because we're only interested in fixing pictures, not organizing them, we'll ignore the Organizer and focus on the Editor.

Within the Editor, you have two main ways to fix a picture—via the Standard Edit mode or the Quick Fix mode. The Standard Edit mode offers a slew of editing tools you can use to make sophisticated fixes; the Quick Fix mode offers a more limited selection of tools for quick and dirty editing operations. Which mode you use depends on the type and severity of the problem you need to fix.

You select the mode you want from the Quick Fix or Standard Edit button at the upper right of the Elements desktop, as shown in Figure 1.1. We'll examine each mode separately.

Figure 1.1

Click a button to select either the Standard Edit or Quick Fix mode.

Quick Fix Mode

If you're like me, you don't want to learn a lot of complicated commands and procedures when it comes to fixing your pictures. If at all possible, you prefer the one-button solution—which is where the Quick Fix mode comes in.

Navigate the Quick Fix Workspace

The Quick Fix workspace, shown in Figure 1.2, is where you'll find most of Elements's one-button fixes. These automated operations are located in a separate pane on the right side of the work area; the picture you're working on appears in the big window in the middle of the screen.

The main elements of the Quick Fix workspace include

- **Menu bar**—Has the standard pull-down menus for various types of operations (no surprises here).

- **Shortcuts bar**—What other programs might call a *toolbar*, this shortcuts bar contains buttons for key program operations.
- **Options bar**—Somewhat unique to this program, this provides options for the currently selected tool. What you see on the Options bar changes depending on which tool you select.
- **Toolbox**—This strip down the left side of the workspace hosts the selected editing tools available in the Quick Fix mode. (More editing tools are available in the Standard Edit mode.)
- **Active image area**—Simply the picture with which you're currently working.
- **Photo Bin**—Displays thumbnails of all the pictures you currently have open; click a thumbnail to display the picture in the active image area for editing.

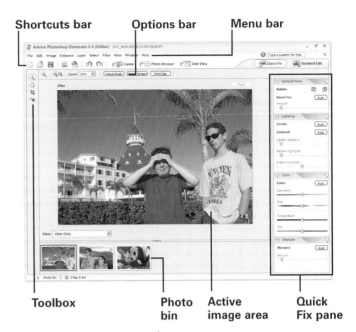

Shortcuts bar **Options bar** **Menu bar**

Toolbox **Photo bin** **Active image area** **Quick Fix pane**

Figure 1.2
Elements's Quick Fix workspace.

Apply Quick Fix Operations

Just what can you fix in the Quick Fix mode? Elements offers four types of fixes, as detailed in Table 1.1.

Table 1.1 Quick Fix Operations

Category	Fixes
General Fixes	Click the **Rotate** buttons to rotate the picture 90° left or right.
	Click the **Auto Smart Fix** button to improve almost everything about a picture—color, shadows, and highlights.
	Move the **Amount** slider to the right for a more noticeable improvement; move the slider to the left for a more subtle adjustment.
Lighting	Click the **Auto Levels** button to increase the contrast and adjust color levels.
	Click the **Auto** button next to the Contrast label to increase the contrast without affecting the color levels.
	Adjust the **Lighten Shadows**, **Darken Highlights**, and **Midtone Contrast** sliders to fine-tune a picture's brightness and contrast levels.
Color	Click the **Auto Color** button to improve a picture's color levels.
	Adjust the **Saturation** slider to increase or decrease the amount of color.
	Adjust the **Hue** slider to change the colors in a picture.
	Adjust the **Temperature** slider to make a picture warmer (more red) or cooler (more blue).
	Adjust the **Tint** slider to make the colors more green or magenta.

TIP

Many of these Quick Fix operations are also available from the pull-down Enhance menu. The nice thing about the Enhance menu is that it's accessible from either the Quick Fix or the Standard Edit workspace—so you don't have to switch to Quick Fix mode to make a quick fix.

TIP

You can perform more than one fix at a time in the Quick Fix mode; just keep selecting fixes, one after another. If you want to undo *all* the fixes you've made, click the **Reset** button.

Table 1.1 Continued

Category	Fixes
Sharpen	Click the **Auto Sharpen** button to make the details in a picture sharper.
	Adjust the **Amount** slider to increase or decrease the amount of sharpness in a picture.

As you can see, these Quick Fix operations cover most of the common problems you're likely to encounter with your pictures. In most cases, you can fix a picture just by clicking one of the Auto buttons. And with more troublesome problems, you can use one of the adjustment sliders to fine-tune the look of your photo.

I particularly like the Smart Fix operation, which adjusts pretty much everything all at once. I suggest applying Smart Fix to all your photos, whether you think they need it or not. In most cases, it subtly improves the look of your photos. On those occasions when it doesn't improve things—or actually makes your picture look worse—click the **Reset** button (above the active image area) to undo the smart fix.

Standard Edit Mode

When you have a more vexing problem, you need more powerful editing tools than offered in the Quick Fix mode. For these more complicated fixes, you need to switch to the Standard Edit mode.

Navigate the Standard Edit Workspace

As you can see in Figure 1.3, the Standard Edit workspace is a bit busier than the Quick Fix workspace because of all the additional tools available.

The key elements of the Standard Edit workspace include

- **Menu bar**—Same as in the Quick Fix mode, it has all the standard pull-down menus.
- **Shortcuts bar**—Also the same as in the Quick Fix mode. What other programs might call a *toolbar*, this contains buttons for key program operations.
- **Options bar**—The same as in the Quick Fix mode, with options for the currently selected tool.
- **Toolbox**—As in the Quick Fix mode, this is a strip of buttons for all available editing tools; as you can see, a lot more tools are available in the Standard Edit mode.

Shortcuts bar **Menu bar** **Options bar** **Palette Bin**

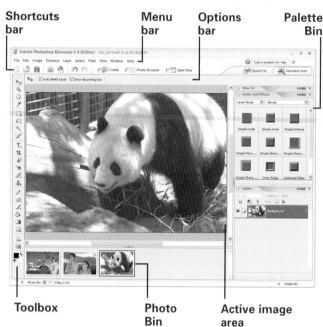

Toolbox **Photo Bin** **Active image area**

Figure 1.3

The Photoshop Elements Standard Edit workspace.

- **Palette Bin**—This element is unique to the Standard Edit mode; it's a place to dock all of Elements's editing palettes. Click a right-arrow button to expand a palette, or click a down-arrow button to shrink the palette. You can also click and drag a palette out of the Bin to display it in a floating window.

- **Active image area**—Same as in the Quick Fix mode, it's the picture you're currently working on.

- **Photo Bin**—Also the same as in the Quick Fix mode, it displays thumbnails of all the pictures you currently have open.

As you might suspect, all these additional tools and palettes provide more picture-fixing power, which makes the Standard Edit mode ideal for working on your most hard-to-fix pictures.

Use Standard Edit Tools

Elements uses two types of instruments to edit your photos—tools and palettes. The differences between tools and palettes seem kind of arbitrary to me; the main distinctions appear to be where each item is located and how it works.

Let's start by looking at Elements's tools, which are found along the left side of the Standard Edit workspace in the Toolbox, shown in Figure 1.4. You select a tool by clicking its button; this changes both the shape and the nature of the cursor, so the cursor becomes the tool you selected. For example, if you select the Eyedropper tool, the cursor changes into a little eyedropper.

Note that some buttons in the Toolbox access more than one tool. If you see a little triangle in the lower-right corner of a tool button, that means that there are several related tools from which you can choose. Right-click that button to display a pop-up menu that lists the tools. For example, if you right-click the **Brush** tool button, the pop-up menu (shown in Figure 1.5) lets you choose from the standard Brush tool, the Impressionist Brush tool, or the Color Replacement tool.

When you select a tool, the Options bar changes to reflect options specific to that tool. For example, when you select one of the Brush tools, the Options bar displays options for the type and size of the brush, brush mode and opacity, and so on. When you select the Crop tool, the Options bar displays options for the width and height of the crop. And so on.

I won't go into all of Elements's available tools here; we'll address specific tools when it's time to use them, throughout the book. All you have to remember is that the tools are in the Toolbox—and that some tools are accessed via a pop-up menu.

NOTE

Four of the most popular tools are also available in Quick Fix mode—Zoom, Hand, Crop, and Red Eye Removal.

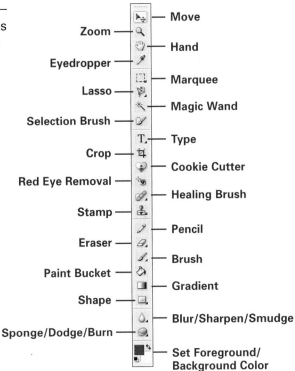

Zoom — Move
Eyedropper — Hand
Lasso — Marquee
Selection Brush — Magic Wand
Crop — Type
Red Eye Removal — Cookie Cutter
Stamp — Healing Brush
Eraser — Pencil
Paint Bucket — Brush
Shape — Gradient
Sponge/Dodge/Burn — Blur/Sharpen/Smudge
Set Foreground/Background Color

Figure 1.4

Tools in the Toolbox.

Figure 1.5

Selecting from multiple Brush tools.

TIP

Hover your cursor over a tool button to display the name of the tool.

Figure 1.6

Displaying a palette in the Palette Bin.

Use Elements's Palettes

Photoshop Elements includes another kind of tool, called a *palette*, that you can also use to make changes to your pictures. You won't find palettes in the Toolbox, however; they're located in a different place on the desktop, and work in a slightly different fashion.

Elements stores all its palettes in the Palette Bin on the right side of the Standard Edit workspace, shown in Figure 1.6. Expand a palette to view its contents, or use your mouse to pull any palette into its own floating window.

Each palette has its own unique options and controls. Again, I won't get into the details of each palette here; we'll address specific palettes when it's time to use them for specific tasks.

Work with Layers

Before we end this little overview and get down to the task of fixing bad pics, we need to take a look at one particular type of palette that you'll use a lot throughout this book—the Layers palette. This palette is quite useful but a little difficult to understand.

The concept behind layers is deceptively simple. By default, any photograph you take consists of a single layer—it's a flat, two-dimensional picture, after all. But if you could overlay semitransparent layers on top of the picture, you could alter the way the photo appears.

Let's take a simple example. We start with a black-and-white picture, consisting of a single layer—nothing complicated yet. But if we add a second layer to the picture, and tint that layer red, then the picture we see (the combination of the two layers) isn't black and white anymore; it's tinted red.

Now imagine all sorts of filter layers applied to your pictures—dark filters, light filters, colored filters, soft-focus filters, you name it. And imagine using filters over only part of you picture, so that you alter only selected elements. It's easy to see how Elements's Layers feature becomes a very powerful picture-editing tool.

To work with layers, you use the Layers palette, shown in Figure 1.7. The main part of the palette shows each layer in your picture as a thumbnail. The highlighted layer is the active layer you're currently working on.

The pull-down list at the upper left of the palette lets you select the *blending mode*, which is kind of like applying different types of filters. More specifically, the blending mode determines how the selected layer blends with the layers beneath it.

The pull-down list at the upper right of the palette determines the opacity of the selected layer. Select a higher opacity to see more of the selected layer and less of the layer beneath it; select a lower opacity to see less of the selected layer (in other words, make it more transparent).

Layers sound complicated, but they're surprisingly easy to use—trust me on this one. Even if you're a newbie at all this photo-editing stuff, you shouldn't be frightened off from using layers. Layers can fix a lot of photos that would otherwise be unusable—which means we'll frequently use layers to fix the problems presented throughout this book.

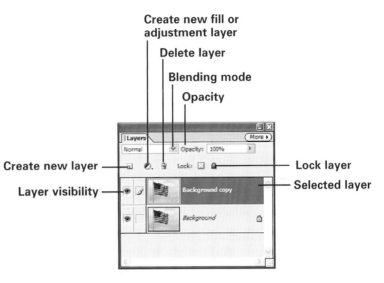

Figure 1.7

The Layers palette.

Before You Fix a Pic, Make a Copy

As you'll discover as you read this book, there are often several different ways to fix any particular picture problem. But here's one important step you need to take before you fix any picture—*make a copy first.*

That's right, you never want to retouch your original picture. What if you make things worse than they were before? (It happens, trust me.) If you're working on a copy, you still have your original you can return to. If you were careless and made irrevocable changes to your original picture, you're out of luck.

It's simple. Never work on the original picture file. Always make a copy and then store your original away in a safe place—in a separate folder or on a photo CD. Only when you have that original file stored away should you feel free to make changes to the copy.

NOTE

Some professional photographers recommend making a copy of a photo's Background layer and then making changes to the copied layer only. This is good advice but somewhat unnecessary if you make a copy of the entire picture file before you start editing.

HOW TO FIX ONLY PART OF A PICTURE

Before we start fixing specific picture problems, there's one more basic operation you need to master—the art of selecting only part of a picture. When you can select a specific area or object in a photo, you can apply all of Elements' editing magic to that area or object, without affecting the rest of the picture.

Why You Don't Always Need to Fix Your Entire Picture

It's possible to take a picture that's only partially perfect. That is, part of the picture looks great, but another part—maybe it's a particular object, maybe it's a larger area—needs a little work.

This often happens with lighting. To get decent lighting in one part of your picture, you might have to sacrifice lighting in another part. If you end up with half of your

"When you can select a specific area or object in a photo, you can apply all of Elements' editing magic to that area or object, without affecting the rest of the picture."

To draw a perfect square instead of a rectangle, hold down the Shift key while you're drawing.

picture too light or too dark, you don't have to correct your entire picture—only those areas that really need changing.

You might also run into a situation where there's just a part of the picture, or maybe a single object, that you'd like to somehow edit. Maybe you want to change the color of a piece of clothing, or make a particular object a little sharper, or even remove something—like an unwanted item or even the entire background.

To make any of these fixes, you need to learn how to select specific parts of a picture. When you select just a section of your photo, you can confine your modifications to the selected section; the rest of the photo remains untouched.

But how do you select just part of a picture to edit? Photoshop Elements offers a number of methods; which one you use depends on the type of area you need to edit. The one commonality is that all of these selection operations are available only within the Standard Edit mode, so click the **Standard Edit** button and let's get to work!

Try This First

Select a Squarish Area with the Rectangular Marquee Tool

If you're really, really fortunate, the area you want to edit is rectangular in shape, such as a sign or the side of a building. That's because it's easy to draw a rectangle, especially when you use Elements' Rectangular Marquee tool.

Follow these steps:

Figure 2.1

Select the Rectangular Marquee tool.

1. From the Toolbox, select the **Rectangular Marquee** tool, as shown in Figure 2.1.

2. Position your cursor at the upper-left corner of the area you want to select.

3. Click and drag the cursor down and to the right.

4. When you release the mouse button, the selected area is surrounded by a flashing rectangular border, as shown in Figure 2.2.

Any tool or palette you now select is applied exclusively to the area within the rectangular selection.

Figure 2.2

The selected rectangular region.

Select a Roundish Area with the Elliptical Marquee Tool

If the area you want to edit is round or elliptical in shape, such as a soccer ball, the Rectangular Marquee tool won't do the job. Instead, you need a slightly different tool—the Elliptical Marquee tool. This tool works just like the Rectangular Marquee tool, except it draws an ellipse instead of a rectangle.

Here's what you do:

1. From the Toolbox, select the **Elliptical Marquee** tool, shown in Figure 2.3. (Right-click [Mac: click and hold] the **Rectangular Marquee** button and select **Elliptical Marquee Tool** from the pop-up menu.)

2. Position your cursor at the upper-left corner of the ellipse you want to draw.

3. Click and drag the cursor down and to the right.

4. When you release the mouse button, the selected area is surrounded by a flashing elliptical border, as shown in Figure 2.4.

Any tool or palette you now select is applied exclusively to the area within the elliptical selection.

Select an Area of Color with the Magic Wand Tool

Generally, most of the areas you'll need to edit are more irregular in shape, which means you'll need to switch to another set of tools.

When you want to select an irregularly shaped area, the first tool to try is the Magic Wand tool. This is an interesting little tool, in that it selects an area based on its color, in contrast to surrounding areas. So, if you need to select a red object against a green background, or a person with a white shirt framed against a dark wall, or even a gray automobile against a deep blue sky, the Magic Wand will do a pretty good job. If, on the other hand, the area you need to select blends in with its surroundings, the Magic Wand isn't so magic.

Using the Magic Wand tool is pretty much a one-click affair. Here's how it works:

1. From the Toolbox, select the **Magic Wand** tool, as shown in Figure 2.5.

2. Click within the area you want to select.

The selected area should now be bordered by a flashing dotted line, as shown in Figure 2.6. Note that only the red area of the Stop sign

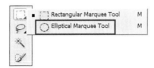

Try This Instead

Figure 2.3

Select the Elliptical Marquee tool.

Figure 2.4

The selected elliptical region.

TIP

To draw a perfect circle, hold down the Shift key while you're drawing.

Figure 2.5

Select the Magic Wand tool.

Figure 2.6

The red area of the Stop sign selected with the Magic Wand tool.

Figure 2.7

Select the Magnetic Lasso tool.

Figure 2.8

Drawing a border with the Magnetic Lasso tool—note the fastening points that snap to the edge of the selected area.

is selected; the white letters and silver screws fall outside of the selection.

This is fine, but sometimes the Magic Wand doesn't automatically select precisely the area you want to edit. If you want to select a larger area based on a broader range of color, try increasing the Tolerance value in the Options bar. (Conversely, to select a smaller area based on a narrow range of color, decrease the Tolerance value.) If you want to select all the areas of your photo of a given color—even if they're not touching—deselect the Contiguous option in the Options bar. You can also use the Add to Selection option to enlarge an area selected with the Magic Wand. When the Magic Wand doesn't select a large enough area initially, click the **Add to Selection** button and then start clicking around the selected area—and keep clicking until everything you want is selected. If you select too large an area, click the **Subtract from Selection** button and click the area you want to delete from your selection.

Try This Instead ## Select a Hard-Edged Area with the Magnetic Lasso Tool

The Magic Wand tool isn't completely magic, of course. Because it relies on color values to make its selections, it's not that useful if the area you want to select is too close in color to its surroundings or is full of several colors.

In these instances, you need to manually draw around the area you want selected. Of course, if the area is perfectly rectangular or elliptical, you can use one of the Marquee tools, as discussed earlier in this chapter. But if the object is irregularly shaped, freehand drawing is called for.

Don't confuse the Magnetic Lasso tool with the standard Lasso tool, which is a true freehand drawing tool—nothing automatic about it. (We'll look at the Lasso tool in the next section.) That said, if you're like me, true freehand drawing is a real pain. When I was a kid, I could *never* color within the lines! Fortunately, Elements offers a drawing tool that automatically snaps to the edges of what you're selecting, in the form of the Magnetic Lasso tool.

The Magnetic Lasso lets you trace roughly over the area you want selected, and then it snaps its border more precisely to the selection, based on how the edge of the area contrasts with the surrounding area. Although the Magnetic Lasso requires some skill to use, I've found it a useful tool for selecting difficult-to-draw areas.

Here's how it works:

1. From the Toolbox, select the **Magnetic Lasso** tool, as shown in Figure 2.7.

2. Click at the point where you want to start drawing.

3. Release the mouse button and start moving the cursor around the area you want selected. The Magnetic Lasso starts drawing a border line, placing *fastening points* at selected intervals, as shown in Figure 2.8. The fastening points automatically snap to the edge of the selected area.

4. When you reach the point where you started drawing, double-click the mouse.

That's it—an automatic border drawn around an irregularly shaped object, as shown in Figure 2.9. If, while you're drawing a border, the Magnetic Lasso doesn't recognize a point on the edge of the selection area, click the mouse to manually add a fastening point there. If you need to undo any fastening points while you're selecting, press the [Backspace] (Delete) key to delete points in reverse order.

By the way, if you find that the Magnetic Lasso tool doesn't snap precisely to a given area, you can try adjusting the following options in the Options bar (shown in Figure 2.10):

- To select an area or object with well-defined edges, such as the edge of a building, enter higher Width and Edge Contrast numbers.

- To select an area or object that has softer edges, such as the hair on a person's head, enter lower Width and Edge Contrast numbers.

Figure 2.9

An irregularly shaped area selected with the Lasso tool.

- To draw a more precise border around a really jagged area, have the Magnetic Lasso use more fastening points by entering a higher Frequency number.

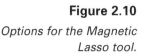

Figure 2.10

Options for the Magnetic Lasso tool.

Select an Irregular-Shaped Area with the Lasso Tool

Last Resort

If you find that the Magnetic Lasso tool doesn't snap precisely to a really jagged edge, you're left with the tool of last resort—the Lasso tool. The regular Lasso tool, as opposed to the Magnetic Lasso, is a pure freehand drawing tool. Assuming that you're good at tracing—and have the patience to trace *slowly* and *precisely* around the edge of an area—this is the way to go. If the area you need to select consists primarily of straight edges, you can use the Polygonal Lasso tool instead of the normal Lasso tool. To use this tool, you click at each corner of the area, where two straight sections intersect. The Polygonal Lasso "fills in" the straight lines between the corners for you.

Figure 2.11

Select the Lasso tool.

Figure 2.12

Freehand drawing with the Lasso tool.

Here's how to use the Lasso tool:

1. From the Toolbox, select the **Lasso** tool, as shown in Figure 2.11. (Right-click (Mac: click and hold) the **Magnetic Lasso** tool button, then select **Lasso Tool** from the menu.)
2. Click at the point where you want to start drawing; then hold down the mouse button and draw a line around the area you want to select, as shown in Figure 2.12.
3. When you reach the point where you started drawing, release the mouse button.

When you use the Lasso tool, you have to draw *very carefully* around the area you want to select. It helps to zoom in to the drawing area and then move the cursor very slowly. If you mess it up, you can press Ctrl+Z (Mac: ⌘-Z) to undo your selection and then try it again.

Figure 2.13

Click the Add to Selection button.

Specific Solutions

Select Multiple Objects

If you want to edit more than one area or object in your picture, and if you want to apply the same editing tool to each one, you don't have to perform separate editing operations on each area. Instead, you can have Elements select multiple areas of your picture and then edit them all at once.

You select multiple areas using the Add to Selection option in the Options bar. When you select this option, you can draw more than one area with one of the marquee and lasso tools, or you can select more than one area with the Magic Wand tool.

It works like this:

1. From the Toolbox, select any of the selection tools.
2. In the Options bar, click the **Add to Selection** button, as shown in Figure 2.13.
3. Draw or select your first area. The selected area should now be bordered by a flashing dotted line, as shown in Figure 2.14.
4. Draw or select another area. Both of your selections should now be surrounded by flashing borders, as shown in Figure 2.15.

Naturally, you can repeat step 4 as many times as you want, to select even more areas in your picture.

Figure 2.14

The first area selected.

Figure 2.15

Multiple areas selected.

Soften the Border of Your Selection

In many instances, it's okay to have a "hard" border between the area you're editing and the rest of your picture. Sometimes, however, it's better to soften the border, so the edited area blends in better with its surroundings.

All the marquee and lasso tools (but not the Magic Wand tool) let you soften the edges of your selection via *feathering*. To soften the edge of your selection, all you have to do is enter a value (in pixels) into the Feather box on the Options bar, as shown in Figure 2.16.

When you feather the edge of a selection, you blur the transition from one area to the next. The amount of blurring is specified in pixels; the more pixels you feather, the softer the edge becomes.

If you made a selection with the Magic Wand tool, you can feather after the fact by selecting **Select** > **Feather**. This opens the Feather Selection dialog box, shown in Figure 2.17. Enter a pixel value, and then click **OK**.

Figure 2.16

Soften the edges of a border with the Feather option.

Figure 2.17

Options for feathering.

TIP

You can use the Select > Feather operation to soften the edges of any selected area, including those selected by the marquee and lasso tools.

HOW TO FIX PICTURES THAT ARE TOO BIG OR TOO SMALL

ZOOMING IN ON THE MOST IMPORTANT PART OF THE PICTURE

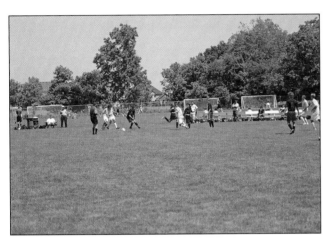

Before

After

"When the important part of your picture is too small, it's time to crop that picture down to size"

When the important part of your picture is too small, too far away, off-center, or inadvertently overshadowed by something else in the picture, it's time to crop that picture down to size. When you crop a picture, you cut off the unwanted parts, effectively zooming in on the part of the picture you want to keep. It's a great way to improve a picture's composition, after the fact.

Why Some Pictures Need Cropping

Cropping is one of the most important tools available to the digital photographer. It lets you fix pictures that are just a little off-center—as well as those where the subject is positioned too far in the background.

What types of pictures can benefit from cropping? Typically we're talking about photos in which you were either too far away from the subject or didn't center the subject properly in the shot.

For example, our first photo is taken from the sidelines during a youth soccer tournament. You've taken hundreds of photos just like this; the problem is that you can't get close enough to the action, so you end up capturing more than you really need and hope that the real action ends up *somewhere* in the shot. What you really want is to zoom in on the action, which you can effectively do by cropping around that area of the picture.

Soccer action, taken too far away.

If you crop too much out of a picture, you can end up with too few pixels left for a quality print. This is especially true if you shot at a low resolution, with a low-megapixel camera, or at a small photo size.

Our second photo shows another picture where the photographer didn't get quite close enough to the subjects. The two gentlemen here are well posed and look great in their tuxedos, but they're standing a little too far away from the camera. Now we need to zoom in on the photo to bring these two handsome gents front and center—which is where cropping comes in.

The groom and the best man, just a little too far away from the camera.

TIP

If necessary, you can fine-tune the area to be cropped by dragging the handles at the corners of the selection.

When you crop out those parts of the picture you don't want, you make the subject of the photo that much bigger in relation to what's left. It's kind of like blowing up that part of the picture. So, when you crop the first photo, you zoom in on the kids with the ball and bring them closer to the lens; when you crop the second photo, the two tuxedoed gents end up positioned front and center in the frame. And you do this all with Photoshop Elements's Crop tool, from either the Standard Edit or Quick Fix mode.

Perform a Freehand Crop with the Crop Tool

Cropping a picture with Elements's Crop tool is as easy as drawing around the part of the picture you want to keep and then double-clicking a button. Everything outside the area you select is cropped, or cut off. Here's how it works:

1. From the Toolbox, select the **Crop** tool, shown in Figure 3.1. Your cursor now changes into the Crop tool shape.

2. In the Options bar, shown in Figure 3.2, click the **Clear** button.

3. Position the cursor at the upper-left corner of where you want the crop to start, as shown in Figure 3.3.

Try This First

Figure 3.1

Select the Crop tool.

| 📐 | Preset Options: ▼ | Width: | ⇄ Height: | Resolution: | pixels/inch ▼ | Front Image | Clear |

Figure 3.2

Click the Clear button in the Options bar.

Figure 3.3

Position your cursor at the upper-left corner of the area to crop.

Figure 3.4

The crop area selected; everything outside the selected area will be cropped off.

4. Click and hold the mouse button while you draw down and to the right, until you've selected the entire region you want to keep in your final picture.

5. Release the mouse button; the selected area is surrounded by a flashing rectangular border and the area outside the selection dims, as shown in Figure 3.4.

6. Double-click within the selected area to make the crop.

When you make the crop, everything outside the selected area is deleted. The effect is to zoom in on the most important part of the picture, as you can see with our soccer photo—which is a lot more exciting cropped than it was before.

Cropping to the most exciting action in our soccer photo.

Try This Instead

Crop to a Specific Size

Cropping is a relatively easy procedure. The only problem is that, more often than not, you end up with a cropped picture that isn't quite the standard size for photo prints. This is a big problem when you want to print on standard-size photo paper or put your picture in a standard-size frame; if the picture's too small, you end up with white space on one side of your print.

> **TIP**
>
> To cancel a crop in progress, just press the **Esc** key.

To make sure your final picture is a standard print size, you need to specify the dimensions of the area you want to crop to. There are two ways to do this. If you're cropping to a standard photo size (4" × 6", 5" × 3", 5" × 4", 5" × 7", or 8" × 10"), you can select the size from the Preset Options list on the Options bar. If you're cropping to a custom size, enter the desired dimensions in the Width and Height boxes in the Options bar.

For example, if you want to end up with a standard 5" × 7" print, pull down the Preset Options list and select **Crop 5 inch x 7 inch 300 ppi**. If you want to end up with a custom 4" × 4" print, enter **4** in the **Width** box and **4** into the **Height** box. (You can also enter a desired final resolution—in pixels per inch—into the Resolution box.)

These options constrain your crop to the shape necessary to result in the selected dimensions. Then when you select the crop area, the height and width automatically adjust in conjunction with each other.

Here's how it works:

1. From the Toolbox, select the **Crop** tool.

2. Select a print size from the **Preset Options** list in the Options bar, or enter the desired values (in inches) into the **Width** and **Height** boxes, as shown in Figure 3.5.

If you want, you can rotate your picture while you're cropping it. Just move your cursor outside the border of the selected area until the cursor changes to a curved arrow; then click the mouse button and drag your mouse to rotate the selection.

Figure 3.5

Selecting the size of your cropped picture.

3. Position the cursor at the upper-left corner of where you want the crop to start.

4. Click and hold the mouse button while you draw down and to the right, until you've selected the entire region you wish to keep in your final picture. Note that the height and width adjust automatically to maintain the dimensions you selected.

5. Release the mouse button; the selected area is surrounded by a flashing rectangular border and the area outside the selection dims, as shown in Figure 3.6.

6. Double-click within the selected area to make the crop.

The result, shown here, is a cropped picture that prints at the precise size you specified.

Figure 3.6

The crop area selected and constrained to the selected dimensions.

The two groomsmen, cropped to a specific size to create a larger portrait.

How to Avoid Cropping

If you learn how to better compose your pictures, you won't have to crop as much. That means getting the subject front and center in the shot, not off to one side.

It also helps if you can get as close as possible to your subjects. This can be accomplished by using your camera's zoom lens; the greater the zoom factor, the closer you can bring far-away subjects. And don't forget to use your feet; getting an extra step or two closer to your subject might be all you need to shoot a great picture, no cropping necessary.

MAKING YOUR PICTURES SMALLER FOR THE INTERNET

"When you want to send or use your digital photos online, you need to use Elements to make them smaller—100KB or less."

Whether your picture is a close-up or a long shot, it is saved as a digital file on your computer. If you shot with a large-megapixel camera at high resolution, the size of that file is pretty large—probably 2MB or more in size, too large to send comfortably via email or to include on a Web page. When you want to send or use your digital photos online, you need to use Elements to make them smaller—100KB or less.

Why You Need Smaller Pictures Online

When we talk about picture size, there's really two different things we're talking about. First, there's the physical size of the picture—how many inches or pixels wide and tall it is. Second, there's the size of the digital picture file, in kilobytes (KB) or megabytes (MB). There's also the picture's *resolution*, which affects both these measurements.

Resolution

We'll start by talking about picture resolution, which measures how many pixels there are to the inch. The higher the resolution, the more pixels per inch. So, a picture shot at 300 pixels/inch is twice as sharp as a picture shot at 150 pixels/inch.

When it comes to making prints of your photos, the higher the resolution the better, as you'll learn in the next chapter. But when it comes to putting pictures on the Web, all that extra resolution is wasted because computer monitors display a fixed number of pixels. So higher-resolution pictures aren't any sharper on the Web—they're just *bigger*.

Bottom line? When you're readying pictures for the Web, set the resolution at 72 pixels/inch. Anything higher is wasted.

Physical Size

Now let's examine how resolution affects the physical size of the picture. If your picture is too large, Web page visitors have to scroll (either down or sideways) to view the entire picture. It's better to constrain the physical dimensions so your pictures can be viewed without scrolling.

How small do your pictures need to be? Assuming that there are no other constraints (such as a template space your picture needs to fit within), you probably don't want your photos to exceed 800 pixels in width. That way, your photo will fit easily on a screen set for 800 × 600 resolution, which is a common setting. You probably don't want to exceed 600 pixels in height, for the same reason.

The lesson here is that if you shoot big photos at high resolution, you end up with pictures that are way too tall and wide to display on a typical Web page. To make them fit within a typical Web browser window, you need to either shrink your photos physically or reduce their resolution.

File Size

A picture's physical size also affects the file size because a larger picture contains more pixels, and more pixels result in a larger file. In addition, the file size is affected by the picture's resolution because higher resolution means more pixels. The more pixels you shoot, the larger the resulting file.

File size matters when you need to send a file to someone via email. The larger the file size, the longer it takes for you to send the email, and the longer it takes for the recipient to download the attached file to her inbox. In fact, if the attached file is too big, some Internet service providers will block it completely!

And that's not all; file size is also important when you're posting pictures to a Web page. The larger the picture files, the longer it takes for the page to load.

So, let's all agree that size is important—and, in this instance, smaller is better.

Let's look at a typical 5'' × 7'' color photo shot at 300 pixels/inch resolution. The resulting file size is a little over 9MB—way too big to send via email or download from a Web page. If we reduce the resolution to 72 pixels/inch, the file shrinks to just 532KB—still big, but considerably easier to handle than before. And if we go on to reduce the physical size of the picture to 2.5'' × 3.5'', we shrink the file even more, to just 133KB, which is almost small enough for broadband email.

To reduce the file size further, you can increase the compression used to create the final file. When you're working with JPEG format files (which is the Web standard), the original picture file is compressed to some degree by selectively discarding picture detail. (This is part of the file format and is done automatically.) When you're saving to JPEG format, Photoshop Elements lets you choose the amount of compression to apply. High compression results in smaller file sizes, with some compromise in picture quality. Low compression provides the best picture quality, but at the expense of larger file sizes.

The decision is possibly a little different when you're emailing pictures to friends and family. If the photo you send is intended for online viewing only, by all means use the smaller file size. But if the recipient will want to print the photo when he receives it, you'll have to suck up the bandwidth and send a larger, higher-resolution file. That's because a picture optimized for the Web isn't high-enough quality for making photo prints.

NOTE

There are other factors, such as color depth and file format compression, that also affect file size—but they're not as critical as physical size and resolution.

TIP

As a rule of thumb, you should keep files designed for a Web page to no more than 50KB in size. That's also a good size for emailing, although you might be able to sneak up to 100KB if both you and the recipient are on broadband connections.

NOTE

How important is picture quality on the Web? The answer is, in most cases, not very. When you're putting pictures on a Web page and you have to choose between file size or picture quality, choose the smaller file.

Use the Save for Web Feature

Okay, now that you understand the value of getting small, let's deal with a real-world situation. You have a high-resolution photo in JPEG, TIFF, or RAW format that you want to send to your friends via email. It's time to start shrinking, but you don't want to go through a lot of fuss or muss. What do you do?

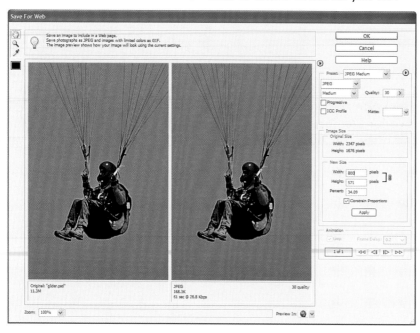

Figure 4.1

Reduce file size and resolution in the Save for Web dialog box.

The fastest way to reduce the size of your photo is to use Elements's Save for Web operation. This operation consolidates all your resizing and quality operations into a single dialog box. Here's how it works:

1. Select **File** > **Save for Web** to open the Save for Web dialog box, shown in Figure 4.1.

2. Go to the New Size section, make sure the **Constrain Proportions** option is checked, enter a new **Width** or **Height** (in pixels), and then click the **Apply** button. (Try not to exceed 800 pixels in width or 600 pixels in height—and smaller is better.)

Figure 4.2

Save your new file.

3. Move up to the Settings section of the dialog box, pull down the **Preset** menu, and select one of the JPEG options—**JPEG Low** (for smallest file size), **JPEG Medium**, or (for best quality) **JPEG High**. If you're not sure which value to select, select **Medium**—it represents a decent compromise between file size and picture quality.

4. The original file size is shown underneath the left picture; your new file size is shown underneath the right picture. There's also an estimation of how long it would take to download the file over a slow dial-up Internet connection. If you like these numbers, click the **OK** button.

5. This opens the Save Optimized As dialog box, shown in Figure 4.2. Enter a name for the new file and click **Save**.

Your photo is saved as a smaller, lower-resolution JPEG file. You can now send the photo via email or upload it to a Web page.

Resize Your Picture Incrementally

Try This Instead

If your original photo is extremely large and sufficiently high resolution, you might not like the results you get with the Save for Web option. When you go from really big to really small in one step, the resulting image is often a tad soft, as you can see in Figure 4.3, which shows the detail of a resized picture—note the jaggies along the diagonal edges.

If this is the case, consider resizing your image in increments, sharpening it at each step with Elements's Unsharp Mask filter. (It may sound counterintuitive, but the Unsharp Mask filter actually *sharpens* the image.) Although this is a more involved procedure than the Save for Web operation, reducing your image in baby steps can often produce better-looking results.

Figure 4.3

Detail from a formerly large image resized too much in a single step.

Step One: Reduce the Resolution

The first step in this process is reducing the picture's resolution to the Web standard 72 pixels per inch. Here's how to do it:

1. Select **Image** > **Resize** > **Image Size** to open the Image Size dialog box, shown in Figure 4.4.
2. Uncheck the **Resample Image** option.
3. Go to the Document Size section of the dialog box and enter a **Resolution** value of **72**.
4. Click **OK** when done.

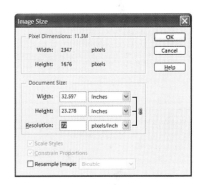

Figure 4.4

Lower the image resolution in the Image Size dialog box.

Step Two: Shrink the Picture—Then Sharpen It

Now we'll start reducing the image size, again using the Pixel Dimensions section of the Image Size dialog box:

1. Select **Image** > **Resize** > **Image Size** to reopen the Image Size dialog box, as shown in Figure 4.5.
2. Check both the **Constrain Proportions** and **Resample Image** options.
3. By default, the **Height** and **Width** controls in the Pixel Dimensions section are displayed in inches. Change this by pulling down the units of measurement menu and selecting **Percent**.
4. Still in the Pixel Dimensions section, enter the value of **90** percent into either the **Width** or **Height** box.
5. Click **OK** to close the dialog box.

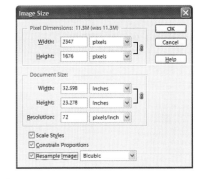

Figure 4.5

Use the Pixel Dimensions section of the Image Size dialog box to resize your photo.

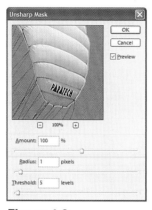

Figure 4.6

Sharpening your smaller picture with the Unsharp Mask.

Figure 4.7

Getting ready to save your file in JPEG format.

Figure 4.8

Setting your picture's quality options.

6. Now we want to sharpen our newly resized picture. Select **Filter** > **Sharpen** > **Unsharp Mask** to open the Unsharp Mask dialog box, shown in Figure 4.6.

7. Select the following values: **Amount**, **100%**; **Radius**, **1** pixel; **Threshold**, **5** levels.

8. Click **OK** to apply the filter and close the dialog box.

Obviously, that one single resizing won't make your picture small enough. So you'll need to repeat this resizing procedure (steps 1–8) until your picture is the desired size, in pixels.

Step Three: Save the Smaller Picture

Once your photo is small enough, you need to save the resized picture—in JPEG format. Here's how to do it:

1. Select **File** > **Save As** to open the Save As dialog box, shown in Figure 4.7.

2. Enter a name for the file into the **File Name** box; then select **JPEG** from the **Format** menu.

3. Click the **Save** button; this opens the JPEG Options dialog box, shown in Figure 4.8.

4. Drag the slider to the left to reduce the picture quality and create a smaller file; drag the slider to the right to improve the picture quality and create a larger file. (Or just pull down the **Quality** menu and select the **Low**, **Medium**, **High**, or **Maximum** quality level.) The resulting file size is shown at the bottom of the dialog box, in the Size section (providing you check the Preview option, of course).

5. Click the **OK** button to save the file.

The result of all this trouble should be a slightly sharper lower-resolution image, as you can see in Figure 4.9. Is it worth it? That's for you to decide—although most users are happy with the results from the Save for Web operation.

How to Avoid Resizing—or Not

If you know you're taking a picture for Web use only, you can eliminate some of the resizing problem by shooting at the lowest resolution your digital camera supports. This gives you a smaller-sized file, although you still might need to adjust the physical size of the picture to fit within your Web page's pixel parameters.

That said, there are a couple of good reasons you might not want to shoot at a low resolution, even if you're shooting for the Web.

First, if you take a photo you really like and decide it would make a great print, you're pretty much out of luck if you shot it at too low a resolution. As you'll learn in Chapter 5, "Making Your Pictures Larger for Prints," you *can* resize smaller pictures and increase resolution if you have to, but the process isn't foolproof and the results are sometimes less than ideal. If you think there's any chance you might want to make a print, shoot the photo at a higher resolution; it's easier to reduce resolution than it is to increase it.

ot of editing to a picture , it's best to start with as The more pixels you have dits you make, the better

the highest possible resolu- g. It's better to start big and out enough picture infor-

Figure 4.9

Detail from our previous picture after being resized in increments.

TIP

To see how fast your picture downloads over various speed connections, click the **Preview Menu** button (the little arrow at the upper right of the preview pictures) and select a new **Size/Download Time** setting.

NOTE

Because the picture proportions are constrained, changing the value of one dimension automatically changes the other.

MAKING YOUR PICTURES LARGER FOR PRINTS

"To create the best-looking prints, you need to increase the size and resolution of your pictures."

Printing a digital photo isn't as simple as you might think—especially if you want the best quality prints. That's because many digital photos are taken at low resolution, which results in poor-quality prints. You also might have to deal with pictures optimized for Web use, which are often much smaller than you want to print. To create the best-looking prints, you need to increase the size and resolution of your pictures.

How to Print a Small Picture Big

There are two factors you need to take into account when you want to make a photo print—the picture's *resolution* (expressed in pixels per inch) and the picture's *physical size*. To make a high-quality print, you need to start with a high-resolution picture. And, to avoid a loss in quality when printing, your digital picture needs to be sized at least as large as the print you want to make.

More Resolution Is Better

Many low-priced digital cameras take pictures at a relatively low resolution—often as low as 72 pixels per inch. Although this resolution is fine for viewing on the Web, it's just not high enough for making quality prints. The lower the resolution, the fewer dots per inch in your print; as you might expect, more dots make for a sharper picture.

How much resolution do you need? For Web use, 72 pixels per inch is the standard. If you plan on printing to a home color inkjet or laser printer, 150 pixels per inch should be adequate. If you're sending your photo to a professional photo printer, however, you'll need at least 300 pixels per inch to produce an acceptable print.

To demonstrate, Figure 5.1 shows a picture at 300 pixels per inch—an acceptably high resolution that produces very sharp edges. Figure 5.2 shows the same picture at just 72 pixels per inch; note the jagged edges and blockiness in the details.

So, before you click that Print button, you probably need to increase the resolution of your pictures. Fortunately, increasing a picture's resolution is relatively easy to do; Elements can easily trade off resolution for picture size. That is, Elements can increase the number of pixels per inch, but doing so reduces the number of inches, in terms of the height and width, of your picture. That's because the total number of pixels stays the same; increase one variable, and the other has to decrease to compensate.

Figure 5.1

A picture at 300 pixels per inch—note the nice sharp edges.

Figure 5.2

The same picture at 72 pixels per inch—note the jagged edges.

A Bigger Size Is Better

Which, of course, introduces a new problem. When you increase the picture's resolution, you decrease the physical size, to the point that your picture might now be smaller than you want to print. For example, if your picture now measures 2 1/2'' × 3 1/2'' and you want to make a 5'' × 7'' print, your picture is too small by half. If you try to print the picture now, it will be blown up to fit the larger size, which effectively reduces the resolution by half—a less-than-ideal compromise because this prints each pixel in the picture at twice its normal size.

For example, Figure 5.3 shows a picture that looks good enough at a smaller size. However, when you print it larger (as shown in Figure 5.4), you can see how there's not enough detail to make a crisp print; it looks fuzzy and blocky and just not good enough to print.

What you need to do, then, is increase the size of your picture without changing the resolution. This is a trickier procedure, but it can be done—although you should know that the larger you make your picture, the less sharp it will be. You're effectively blowing up a small picture to fill a large space, and the end result might look somewhat pixilated. Fortunately, you can minimize this effect, as you'll learn later in this chapter.

Figure 5.3

A picture might look good at a small size...

Figure 5.4

...but not have enough detail when you print it larger.

Increase the Resolution

The first thing you often need to do when you're preparing a photo for printing is to increase its resolution. Depending on the size of the original photo and the size of the print you want to make, this might be all you need to do before you print.

Of course, this is less of an issue when you're printing on a home printer. Elements will alert you when you're printing at too low a resolution, by displaying an alert message in the Print Preview dialog box. This message, like the one in Figure 5.5, tells you that "your image will print at less than 150 dpi at the present size"—which means you should either try printing at a smaller size or work to increase the picture's resolution.

Try This First

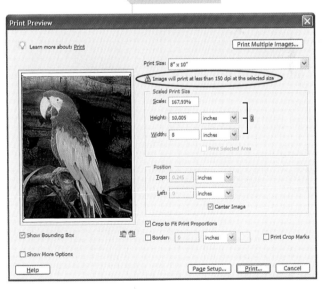

Figure 5.5

Elements warns you when you need to increase a picture's resolution for printing.

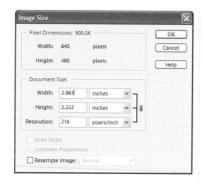

Figure 5.6

Getting ready to increase the resolution of a picture— be sure to uncheck the Resample Image option.

If you see this alert message, or if you want to send a low-resolution picture to a professional photo printer, here's how you can increase the picture's resolution:

1. Select **Image** > **Resize** > **Image Size** to open the Image Size dialog box, shown in Figure 5.6.

2. As you'll learn later in this chapter, resampling an image causes Elements to maintain a given physical size by interpolating missing pixels. This decreases the quality of the picture, so for now you should turn off resampling, which you do by unchecking the **Resample Image** option.

3. Go to the Document Size section and enter one of the following values into the **Resolution** box: If you're printing on an inkjet printer, enter **150** pixels/inch; if you're sending it to a professional photo printer, enter **300** pixels/inch.

4. You'll notice that, when you increase the Resolution value, the Document Size values automatically decrease. Take note of the new Width and Height; then click the **OK** button.

The picture's resolution is now increased, but the picture itself is now smaller. That's because you turned off the Resample Image option, which kept the total number of pixels in the picture constant. More pixels per inch thus results in fewer inches, tall and wide.

This might not be apparent to you because, even though the picture is physically smaller, it won't appear smaller onscreen. (That's a function of Elements fitting the picture to the screen.) You can confirm the actual size, however, by turning on rulers around the picture (**View** > **Rulers**). As you can see in Figure 5.7, the actual size shows on the ruler.

Figure 5.7

The resized picture, confirmed against Elements's ruler.

I told you to take note of the new picture size. If the new dimensions are equal to or larger than the size print you want to make, you don't have to do anything else before you print. But if you want to make a larger print than the current dimensions, you'll need to increase the picture size—which we'll do next.

Do This Next ▶ **Resize in a Single Step**

After you get the picture's resolution up to snuff, you can now physically enlarge the picture for printing. If you're not enlarging it too much (no more than 50% or so—say, to turn a 3'' × 5'' picture into a 4'' × 7 1/2''), you can use the Image Size command to resize your image in a single operation.

Here's what you do:

1. Select **Image > Resize > Image Size** to open the Image Size dialog box, as shown in Figure 5.8.

2. Because you want to increase the number of pixels in the picture, you should turn on Elements's resampling feature, which creates new pixels by resampling the existing ones. So, check the **Resample Image** option, along with the **Constrain Proportions** option.

3. Go to the Document Size section and enter a new value for either the **Width** or the **Height**; the other value adjusts automatically.

4. Click **OK**.

That's it—your picture is now larger!

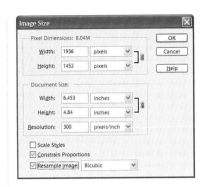

Figure 5.8

Getting ready to increase the size of your picture— make sure you check the Resample Image option.

Resize Incrementally

> Try This Instead

The only problem with enlarging a picture in this fashion is that, when you made the picture bigger, you had to increase the number of pixels used to create the image. Where did those new pixels come from?

When you turned on the Resample Image option, Elements created new pixels by interpolating from the color information of the old pixels. In other words, it guessed at what was needed where and added the new pixels accordingly. The result is that the enlarged picture is a little less sharp than the original, with a little less picture detail.

If you increased the size only a little bit, this loss of sharpness and detail probably isn't noticeable. But if you increased the size a lot— going from a 3'' × 5'' to a 6'' × 10'', for example—you might not be satisfied with the results. That's because Elements had to make some fairly large interpolations. The larger the final print, the more noticeable the problem.

There is a way to minimize this loss of quality, however. When you increase the picture size in small increments, rather than one fell swoop, the picture retains most of its original sharpness and detail. That's because Elements is making several small interpolations rather than one large one, and the differences between each iteration are relatively minor.

So, if you want to create a really big, really sharp print, you need to enlarge your picture one small step at a time. Here's what you need to do:

1. Select **Image > Resize > Image Size** to open the Image Size dialog box.

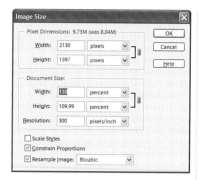

Figure 5.9

Enlarging your picture 10% at a time.

2. Check the **Resample Image** option, along with the **Constrain Proportions** option.

3. Go to the Document Size section and change the units of measurement for **Height** and **Width** to **Percent**.

4. Still in the Document Size section, enter a value of **110** percent for either the **Width** or the **Height**, as shown in Figure 5.9; the other value adjusts automatically.

5. Click **OK** to apply the resizing.

6. Repeat steps 1–5 until you reach the desired document size.

Admittedly, this process can take a while, especially if you're enlarging to poster size. But the results are worth it—the resulting image will be a lot sharper than you get with the simpler method.

How to Avoid the Pixelation Problem

If you think you're going to make a big print of a specific picture, you can avoid most of this trouble by shooting at as high a resolution as your digital camera supports. The higher the resolution— before you start any of the manipulations discussed in this chapter—the larger the resulting picture. Start with a low-resolution photo, and you have to increase both the resolution and the size. Start with a high-resolution photo, and you only have to increase the size.

HOW TO FIX GENERAL PICTURE PROBLEMS

FIXING TILTED PICTURES

Before

After

Do you always hold your camera perfectly level? Have you ever taken a picture that slopes up or down, where everything appears tilted one direction or another?

Taking a level picture is more difficult than it seems. No matter how hard you try to position the horizontal and the vertical, it's easy to end up a few degrees off. If you can't stand even a slightly tilted photo, it's time to call in Photoshop Elements to do some straightening for you.

"If you can't stand even a slightly tilted photo, it's time to call in Photoshop Elements to do some straightening for you."

Straighten the Picture Automatically

Even the most beautiful landscapes can be ruined if the horizon isn't straight, as you can see in this photo. Fortunately, Photoshop Elements offers a one-step solution for tilted pictures—the Straighten Image command. You'd be surprised how often Elements gets it right; this command works especially well if there's a well-defined horizontal line (like a horizon) in your picture.

CAUTION

The automatic Straighten and Straighten and Crop Image commands don't always work that well. If you end up with a image that's still tilted—or, even worse, rotated at a really odd angle—then undo the changes and rotate the image manually, as described next.

A beautiful landscape with a tilted horizon.

Figure 6.1

A rotated picture doesn't fit precisely within the original frame; you need to crop off the white space (which Elements displays in gray) at the corners.

If you use this command by itself, however, you'll end up with some amount of white space in the corners, as shown in Figure 6.1. To get rid of this blank space, you need to crop your picture after you rotate it. Again, Elements anticipates this problem by offering the Straighten and Crop Image command, which performs both operations with a single click. Obviously, this is the command you want to use.

Here's how you go about straightening—and cropping—a tilted image:

1. Select **Image > Rotate > Straighten and Crop Image**.

That's it—there's no step 2! The image is automatically rotated and the extra white space cropped off. In most cases, the results are more than acceptable, as you can see here.

Our newly straightened landscape.

Manually Rotate the Picture

If Elements can't determine how to straighten your image—if there's no defined horizontal or vertical lines—you'll have to straighten your picture manually. You do this with Elements's Free Rotate command, like this:

1. Select **Image** > **Rotate** > **Free Rotate Layer**.

2. Elements now displays a dialog box, shown in Figure 6.2, that asks whether you want to make your picture a layer. Click **OK**.

3. When the New Layer dialog box appears, shown in Figure 6.3, accept the name **Layer 0** and click **OK**.

4. Now you're ready to rotate. Move your cursor to any edge of the photo and the cursor changes into a curved arrow, as shown in Figure 6.4. Click and drag the cursor to rotate the photo in that direction.

5. When you're finished rotating, double-click anywhere within the picture to register the rotation.

6. Now you need to crop off the edges of your newly rotated picture. Select the **Crop** tool from the Toolbox, drag to select the desired final picture area (as shown in Figure 6.5), and then double-click to complete the crop.

Try This Instead

Figure 6.2

Before you rotate, make your picture a layer.

Figure 6.3

Naming the background layer.

Figure 6.4

Use your mouse to manually rotate the picture within the frame.

Figure 6.5

After you've rotated the picture, you need to crop off the corners.

Naturally, the more you rotate your picture, the more you'll have to crop the corners—which results in a smaller picture size. If the rotated and cropped picture is too small, you might need to enlarge it for printing; see Chapter 5, "Making Your Pictures Larger for Prints," to learn more. When you're in rotate mode (what Elements cryptically calls Free Transform mode), you can also move the picture around in the frame. Just move the cursor into the center of the picture, hold down the mouse button, and drag the picture to a new position. Learn more about cropping in Chapter 3, "Zooming In on the Most Important Part of the Picture."

Try This Instead ▶ ## Rotate with a Grid

If you want to be really precise in your rotation, you can display a grid over your picture and line up your picture with that grid. As you can see in Figure 6.6, this makes getting your lines perfectly horizontal (or vertical) easy.

To display a grid over your picture, select **View > Grid**. You can then rotate your picture as you learned previously.

Figure 6.6

Lining up your picture to a grid.

Specific Solutions ▶ ## Rotate an Object or Area Within a Picture

Here's something neat that might come in handy from time to time. Not only can you rotate a complete picture, but you can also rotate any area or object you select within a picture. Got a picture of somebody or something leaning at an odd angle? Then straighten them out—without tilting the rest of the picture.

Here's a picture of a house you might send to family members or submit for a real estate listing. Everything looks great—it's a sunny day, the windows are clean, and somebody moved the old Chevy pickup from the driveway. The only problem is that stupid lamppost, which

is listing dangerously to the left. Who wants to buy a house with a leaning lamppost?

This leaning lamppost spoils an otherwise symmetrical house photo.

What you need to do is tilt that lamppost back to a perfectly vertical position. Here's how you do it:

1. Use one of the **Lasso** or **Marquee** tools to select an area or object within your picture, as shown in Figure 6.7.

2. Select **Image** > **Rotate** > **Free Rotate Selection**.

3. A rectangular border now surrounds your selection, as shown in Figure 6.8. Move your cursor outside this selection until it turns into a curved arrow; then click and drag the cursor to rotate the selected area.

4. When you're finished rotating the selection, double-click anywhere within the selected area to lock in the rotation, and then press **Ctrl+D** (⌘-**D**) to deselect the selection.

5. The only problem with rotating an area or object is that the space originally occupied by the object needs to be filled, as you can see in Figure 6.9. You'll have to use Elements's Paint Bucket or Clone Stamp tool to fill in the now-empty area. (This particular example requires careful application of the Clone Stamp tool to clone the brick pattern into the empty areas.)

Figure 6.7

Selecting an object to rotate.

Figure 6.8

Getting ready to rotate the object

Figure 6.9

When you rotate an object, you leave an empty space where the object used to be.

NOTE

Learn more about selecting areas of a picture in Chapter 2, "How to Fix Only Part of a Picture."

NOTE

Learn how to fill in empty spaces in Chapter 23, "Removing Unwanted Objects (and People!)."

That's it. The lamppost is now vertical, in line with the brick pattern on the house. Much more attractive, don't you think?

The leaning lamppost now stands straighter.

How to Avoid Taking Tilted Pictures

If you're careful about how you frame your photos, you won't have to bother with all this straightening and rotating nonsense. Make sure you hold your camera firmly in both hands, using your left hand to support the camera body and your right hand to focus and snap the shot. When you're setting up the shot, try to line up the horizon or some other point of horizontal reference so that it's parallel with the bottom edge of the viewfinder. And if you have trouble judging true horizontal, invest in a tripod; it'll hold your camera level for you.

FIXING PICTURES THAT ARE TOO DARK

Before

After

"In theory, fixing an underexposed picture is as simple as lightening it up"

The room was too dark. You forgot to use a flash. The sun was behind the clouds. You pressed the wrong button on your camera.

Whatever the cause, your picture is too dark—or, to use the technical term, *underexposed*. Next time around you can avoid the problem by using your flash, turning on a few more lights, or (if your camera has manual controls) increasing the exposure. For now, though, you're stuck with a dark picture.

In theory, fixing an underexposed picture is as simple as lightening it up. The problem is how to add brightness without losing contrast and detail—which is why there are several different approaches you can take to fix a dark picture.

One-Button Brightening with Auto Contrast

See this picture? It was taken indoors in low light with no flash—the only light came from the fixture to the subject's right, and it wasn't near enough. The resulting picture is extremely dark; you can't even see the subject's face. To fix the picture, we want to brighten up its tonal value, as quickly and as simply as possible—to make it look as if we'd actually used proper lighting.

NOTE

Auto Contrast works by mapping the lightest and darkest areas of your picture to white and black, respectively. It isn't terribly effective with pictures that have a limited tonal range—like our current example.

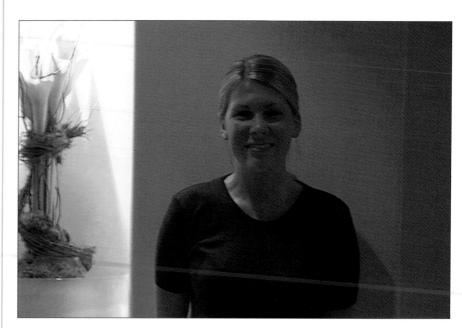

An extremely dark picture taken indoors in low light.

The easiest fix for this type of problem photo is a one-button solution called Auto Contrast, which is tailor-made for fixing dark pictures like this one. When you apply Auto Contrast, Elements automatically adjusts your picture's brightness and contrast to optimal levels.

To apply Auto Contrast, here's what you do:

1. Click the **Quick Fix** button to enter the Quick Fix mode.

2. Go to the Lighting section and click the **Auto** button next to the Contrast label, shown in Figure 7.1.

That's it! In many cases, this simple operation will properly lighten the picture and fix your darkness problem.

Figure 7.1

Applying the Auto Contrast operation.

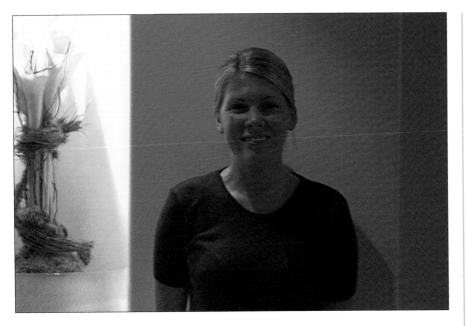

Our dark picture lightened via Auto Contrast—well, not much.

Lighten the Shadows

As easy as Auto Contrast is to use, it doesn't always get the job done. If you've tried the one-touch solution and still have a problem, it's time to take the next step and use Elements's various manual controls.

The first such control we'll try is below the Contrast label in the Lighting section of the Quick Fix page. The Lighten Shadows control lightens the dark areas of your picture, often enough to make the photo viewable again.

Here's how to use it:

1. Click the **Quick Fix** button to enter the Quick Fix mode.
2. Go to the **Lighting** section, as shown in Figure 7.2.
3. Move the **Lighten Shadows** slider to the right until the picture is the desired lightness.

While you're at it, you also might need to nudge the Midtone Contrast slider a tad, probably to the right, to compensate for all the lightening.

Try This Instead

Figure 7.2

Adjusting the Lighten Shadows slider.

Our picture after lightening the shadows.

Try This Instead

Adjust the Brightness and Contrast

Probably the most useful manual controls for fixing dark pictures are the brightness and contrast controls, which are more powerful than the simple Quick Fix controls. You use these two controls to brighten your pictures while still maintaining proper contrast and detail.

You can adjust brightness and contrast from either the Quick Fix or Standard Edit mode. Follow these steps:

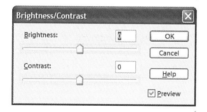

Figure 7.3

Adjusting brightness and contrast, manually.

1. Select **Enhance** > **Adjust Lighting** > **Brightness/Contrast** to open the Brightness/Contrast control, shown in Figure 7.3.

2. Increase the picture's brightness by moving the **Brightness** slider to the right.

3. The brighter you make your picture, the more washed out it will appear—due to a lack of contrast. You fix this side effect by moving the **Contrast** slider to the right.

As you can see, you'll need to play with both the Brightness and Contrast sliders together to achieve the optimal effect.

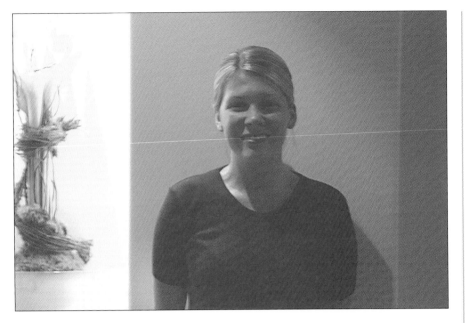

Our picture after adjusting the Brightness and Contrast controls.

Adjust the Black and White Levels

Another way to brighten up a dark picture is to manually adjust the intensity levels of the picture's bright and dark areas. This can get a little complex, especially if your picture is all mid-tones. However, if your picture contains clearly defined white and black areas, this can be the way to go.

You can make this adjustment from either the Quick Fix or Standard Edit mode. Here's how to do it:

1. Select **Enhance** > **Adjust Lighting** > **Levels** to open the Levels control, shown in Figure 7.4.

2. From here, the first thing to do is set the picture's black level; click the **Set Black Point** button (the leftmost eyedropper). Then click your mouse on a point in your picture that you know should be deep black, as shown in Figure 7.5.

3. Next, set the picture's white level; click the **Set White Point** button (the rightmost eyedropper) and then click your mouse on a point in your picture that you know should be bright white, as shown in Figure 7.6.

Try This Instead

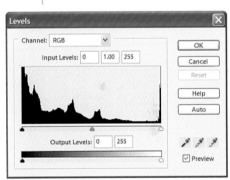

Figure 7.4

Adjusting the bright and dark levels of your picture.

Figure 7.5

Set the black point.

Figure 7.6

Set the white point.

Figure 7.7

Lighten up the picture with the Gray Input Levels slider.

4. We'll ignore the middle, Set Gray Point, button because it tends to affect the picture's color cast. Instead, we'll move to the **Gray Input Levels** slider, which is the middle slider in the middle of the Levels dialog box, right underneath the histogram graph, as shown in Figure 7.7. Drag this slider to the left to further lighten the picture or to the right to darken it.

5. You might need to repeat steps 2 and 3, clicking in different black and white areas in your picture until you get the results you want. When you're satisfied, click the **OK** button to register your changes. This final step isn't always necessary. Most often, setting just the black and white levels will do the job.

As you can see, if you apply this technique carefully, you can obtain really good results.

More precise picture brightening with the Levels control.

Try This Instead ## Add a Brighter Layer

No matter how much you play with the Brightness/Contrast and Levels controls, some pictures simply defy fixing. In fact, the more you fiddle with the sliders, the worse some pictures get. If you have a dark picture that refuses to lighten up (without severe side effects), then it's time to use one of Elements's most powerful features—layers.

As you learned in Chapter 1, "Making Quick Fixes with Photoshop Elements," a layer is like a semitransparent copy of your picture placed on top of the original picture. You make various adjustments

to this semitransparent layer, which has the effect of altering the appearance of the original picture. For our purposes, we want to make the new layer lighter than the original picture; this will make the original picture look brighter, without adversely affecting contrast or detail.

All you have to do is follow these steps:

1. Click the **Standard Edit** button to enter the Standard Edit mode.

2. Start by creating a new layer that's a duplicate of your original picture. You do this by selecting **Layer** > **Duplicate Layer**. When the Duplicate Layer dialog box appears, as shown in Figure 7.8, give the duplicate layer a name (or just accept the suggested name); then click **OK**. That's it—you now have a two-layer picture.

3. Now it's time to work with that duplicate layer. Select the **Layers** palette in the Palette Bin, as shown in Figure 7.9.

4. You should now see the different layers (two, for now) in your picture. The duplicate layer (labeled **Background copy**) should be highlighted; if not, click it to select it.

5. There are two controls (they look like pull-down menus) at the top of the Layers palette. The one on the left is the **Blending Mode** control, and the one on the right is the **Opacity** control. The first thing to do is lighten up the duplicate layer, which you do by pulling down the **Blending Mode** control and selecting **Screen**.

6. You can now select how much this brighter layer affects the original layer by adjusting the opacity. Click the **Opacity** control (it should be set at 100% to start) to display the slider; move the slider to the left for less effect or to the right for greater effect. (A setting of 0% means that the duplicate layer is completely transparent, with zero effect on the underlying picture; a setting of 100% means that the duplicate layer is completely opaque, with maximum effect on the original picture.)

Figure 7.8

Creating a duplicate layer.

Figure 7.9

Working with the different layers in your picture.

If your picture is really dark, you might need to add another (or another and another) duplicate layer. Just repeat the previous steps to add additional layers; be sure you apply the Screen blending mode to each of these duplicate layers.

As you can see, using layers in this fashion has tremendous impact on your pictures. You might find that you want to jump immediately to the layer solution when you have really dark pix to fix—it's that powerful!

TIP

If you're fixing a dark picture shot indoors, chances are the colors are also off somewhat due to the color cast of artificial lighting. To fix this type of problem, use the techniques discussed in Chapter 9, "Fixing Bad Color," before you duplicate any layers.

The best fix of them all, accomplished with Elements's Layers function.

Specific Solutions

Brighten Just Part of a Picture

You might have a picture, like the one here, where part of the picture is too dark and part of the picture is just right. This is a common problem when shooting indoors with a window or other light source in the background; if your camera adjusts to the light, it leaves the rest of the picture underexposed.

You don't want to apply your brightening techniques to the entire picture; if you brighten the whole shebang, the bright part of the picture will get *too* light. You need to brighten just the dark part of the picture—in this example, the sour-faced fellow (my brother, actually) in the foreground.

The person on the right side of this picture is underlit—but you don't want to make the rest of the picture any brighter.

You can apply any of the techniques discussed in this chapter to a selected portion of a picture. All you have to do is select the part of the picture you want to fix and then apply the fix.

Select the Area to Fix

To select the area to fix, use the techniques you learned in Chapter 2, "How to Fix Only Part of a Picture." You can use the Marquee tools to select rectangular or elliptical areas or the Magic Wand or Lasso tools to select irregularly shaped areas. You should also use the Feather command to soften the edges of your selection. When the area is selected, it should look like Figure 7.10.

Figure 7.10

Select the area to brighten.

Quick Fixes

After you've selected the area you want to fix, you can then apply the Auto Contrast, Brightness/Contrast, or Levels operations to the selected area. (If you want to apply Auto Contrast, be sure you select the area in the Standard Edit mode and then switch to the Quick Fix mode.) The effect will apply *only* to the selected area and leave the rest of your photo as-is—the perfect solution to fixing just part of a picture.

Fix It with Layers

It's a little more involved to use layers on a selected part of your picture, although the results are worth the effort. You have to create a new layer based on the selected area and then make adjustments to that layer.

Figure 7.11

A new layer created from the selected area.

To use this technique, you have to be in Standard Edit mode. Here's how it works:

1. After you select the area to edit, select **Layer** > **New** > **Layer Via Copy**. This creates a new layer consisting only of the selected area.
2. Open the **Layers** palette; the new layer (consisting of only the selected area) should be highlighted, as shown in Figure 7.11.
3. Now you can use the Blending Mode and Opacity controls on this new layer. Specifically, change the **Blending Mode** from Normal to **Screen**, and then adjust the opacity as necessary.

The result? The dark area of your picture gets brighter, while everything else remains the same!

TIP

If the selected area is particularly dark, you can duplicate the new layer to apply multiple lighter layers, as discussed previously.

Our final fix—the gentleman on the right is brighter, while the rest of the photo remains unaffected by the changes.

Paint It Lighter with the Dodge Tool

If you need to fix only a small dark area of a photo, there's one more tool you might want to try. Elements's Dodge tool lets you paint a dark area lighter, using your cursor. Here's how it works:

1. From the Toolbox, select the **Dodge** tool, as shown in Figure 7.12. Right-click (Mac: click and hold) the **Sponge** tool button, and then select **Dodge Tool** from the menu.

Figure 7.12

Select the Dodge tool.

Figure 7.13

Select the appropriate options for the Dodge tool.

2. In the Options bar, shown in Figure 7.13, select a mid-sized soft-edged brush. Pull down the **Range** list and select **Midtones**; then set the **Exposure** control to **25%**.

3. Position the cursor over the area you want to lighten; then click and hold the mouse button and drag the cursor over the area, as shown in Figure 7.14. Continue to repaint over an area to brighten it even more.

4. Release the cursor when you're done.

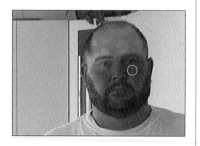

Figure 7.14

Lightening an area with the Dodge tool.

When used properly, the Dodge tool does a decent job of lightening spots in a picture. I wouldn't recommend it for lightening large areas, however. The results can be a bit dodgy (pun intended), which is more noticeable over a larger canvas. Besides, there are more effective tools for those big jobs, as you learned earlier in the chapter.

How to Avoid Taking Dark Pictures

The easiest way to keep your photos from coming out too dark is to use more light! Shooting outdoors generally works fine; if you're shooting indoors, you can open the curtains, turn on all the lights, use your camera's built-in flash, or invest in an inexpensive lighting kit. Do whatever you can to put more light in the room where you're shooting.

You should also read your camera's instruction manual to see whether you can manually adjust the camera's exposure setting. Increase the exposure when you're shooting in a dark room; this lets more light through the lens and thus brightens the picture.

TIP

The key to success with the Dodge tool is the amount of Exposure you select. Experiment with different settings to achieve the best effect.

FIXING PICTURES THAT ARE TOO LIGHT

Before

After

"Just as you can take photos that are too dark, you can also take pictures that are too light"

J ust as you can take photos that are too dark, you can also take pictures that are too light—pictures that look washed out and lack important detail. Fortunately, many of the same techniques you learned (in Chapter 7, "Fixing Pictures That Are Too Dark") to brighten a dark picture can also be used to darken a bright picture—and add back some of that missing contrast.

Try This First

One-Button Darkening with Auto Contrast

Here's a photo, taken outdoors on a bright (although cloudy) day, that's just way too light. All the details are washed out, and the contrast is almost nonexistent. To fix the picture, we need to darken it and add back some of the contrast and detail.

NOTE

Auto Contrast works by mapping the lightest and darkest areas of your picture to white and black, respectively. It isn't terribly effective with pictures that have a limited tonal range.

An overly bright and washed-out picture.

Just as when we were fixing too-dark pictures in Chapter 7, the first thing to try when fixing a too-light picture is the Auto Contrast operation. When you apply Auto Contrast, Elements automatically adjusts your picture's brightness and contrast to optimal levels.

To apply Auto Contrast, here's what you do:

1. Click the **Quick Fix** button to enter the Quick Fix mode.

2. Go to the Lighting section and click the **Auto** button next to the Contrast label, as shown in Figure 8.1.

Yes, it's the exact same one-button solution as you learned in Chapter 7—and it provides similar results. I've found, however, that Auto Contrast works better with too-light pictures than it does with too-dark pictures, so you might not be satisfied with the results you achieve.

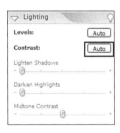

Figure 8.1

Click the Auto button next to the Contrast label.

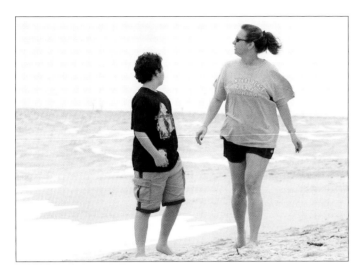

Our too-bright picture darkened via Auto Contrast.

Darken the Highlights

Try This Instead

If Auto Contrast doesn't do the job, or if you end up with a darker picture but without sufficient contrast, you can try another Quick Fix adjustment: the Darken Highlights control. Follow these steps:

1. Click the **Quick Fix** button to enter the Quick Fix mode.
2. Go to the Lighting section, shown in Figure 8.2.
3. Decrease the picture's brightness by moving the **Darken Highlights** slider to the right.

With many photos, adjusting the Darken Highlights control is all you'll need to do. In some instances, however, you'll have to make additional adjustments using the Midtone Contrast control to achieve optimum results.

Figure 8.2

Darkening the picture's highlights.

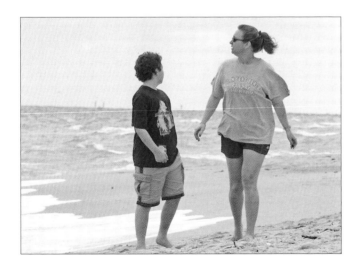

Our picture after adjusting the Darken Highlight control.

Adjust the Brightness and Contrast

When the Quick Fix adjustments don't do the job, you can try Elements's more powerful Brightness and Contrast controls. These controls can darken your picture while still maintaining proper contrast and detail.

Figure 8.3

Adjusting brightness and contrast manually.

You can adjust the brightness and contrast from either the Quick Fix or Standard Edit mode. Here's what to do:

1. Select **Enhance** > **Adjust Lighting** > **Brightness/Contrast** to open the Brightness/Contrast dialog box, shown in Figure 8.3.
2. Decrease the picture's brightness by moving the **Brightness** slider to the left.
3. To adjust the contrast of the picture, move the **Contrast** slider to the left for less contrast or to the right for more contrast.

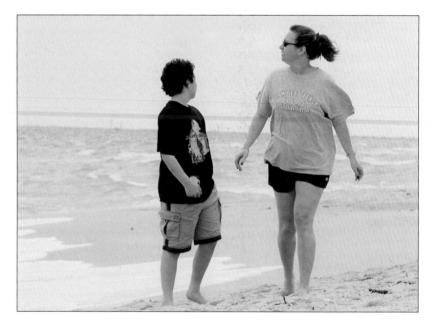

The picture after adjusting the Brightness and Contrast controls.

The result is similar to using the Quick Fix Darken Highlight control, but with a little better contrast.

Adjust the Black and White Levels

Another way to darken an overexposed picture is to manually adjust the intensity of the picture's bright and dark areas, using Elements's Levels control. This operation is easiest if your picture contains clearly defined white and black areas.

You can adjust the levels from either the Quick Fix or Standard Edit mode. Here's how to do it:

1. Select **Enhance** > **Adjust Lighting** > **Levels** to open the Levels dialog box, shown in Figure 8.4.

2. From here, the first thing to do is set the picture's black level. Click the **Set Black Point** button (the leftmost eye-dropper) and then click your mouse on a point in your picture that you know should be deep black, as shown in Figure 8.5.

3. Next, set the picture's white level; click the **Set White Point** button (the rightmost eyedropper) and then click your mouse on a point in your picture that you know should be bright white, as shown in Figure 8.6.

4. We'll ignore the middle, Set Gray Point, button because it tends to affect the picture's color cast. Instead, we'll move to the Gray Input Levels slider, which is the middle slider in the middle of the Levels dialog box, right underneath the histogram graph, as shown in Figure 8.7. Drag this slider to the right to further darken the picture or to the left to lighten it.

5. You might need to repeat steps 2 and 3, clicking in different black and white areas in your picture until you get the results you want. (Each new time you click replaces the previous settings.) When you're satisfied, click the **OK** button to register your changes.

Figure 8.4

Adjusting the bright and dark levels of your picture.

Figure 8.5

Click a black area of your picture.

Figure 8.6

Click a white area of your picture.

Figure 8.7

Further darken the picture with the Gray Input Levels slider.

More precise darkening with the Levels control.

Add a Darker Layer

Just as when you try to lighten a dark picture, sometimes the best way to darken a light picture is to use Elements's Layers feature. This works by creating a duplicate layer that is darker than the current layer; when the new layer is superimposed on top of the current layer, the resulting picture is darker and has much better contrast.

Follow these steps:

1. Click the **Standard Edit** button to enter the Standard Edit mode.

2. Start by creating a new layer that's a duplicate of your original picture. You do this by selecting **Layer** > **Duplicate Layer**. When the Duplicate Layer dialog box appears, as shown in Figure 8.8, give the duplicate layer a name (or just accept the suggested name); then click **OK**. You now have a two-layer picture.

3. Now you need to work with the duplicate layer. Select the **Layers** palette in the Palette Bin, as shown in Figure 8.9.

4. You should now see the different layers (two, for now) in your picture. The duplicate layer (labeled **Background copy**) should be highlighted; if not, click it to select it.

5. To darken the duplicate layer, change the **Blending Mode** setting from Normal to **Multiply**.

6. You can now select how much this darker layer affects the original layer by adjusting the opacity. Click the **Opacity** control (it should be set at 100% to start) to display the slider; drag the slider to the left for less effect or to the right for greater effect.

If your picture is really bright, you might need to add another (or another and another) duplicate layer. Just repeat the preceding steps to add additional layers; be sure you select the **Multiply** blending mode for each of these duplicate layers.

When it comes to darkening extremely overexposed photos, I've found that this approach—as complicated as it is—almost always delivers the best results. If a simple Auto Contrast adjustment doesn't do the job, I jump automatically to this method!

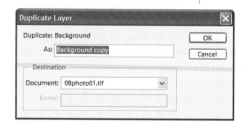

Figure 8.8

Creating a duplicate layer.

Figure 8.9

Working with the different layers in your picture.

Our overexposed photo fixed with the Layers function.

Darken Only Part of the Picture

Specific Solutions

Sometimes you have a picture where only part of the photo is too light. Most commonly, you have a foreground subject that is properly lit, but a background that's way too light—as with this photo, where the sparkling blue waters of La Jolla Cove look great but the sky and cliffs beyond are washed out. (This also happens if you shoot someone standing in front of an open window; if you get the exposure right for the subject, the background will be blooming bright.)

A properly lit foreground with a too-bright sky and background.

In this instance, you don't want to touch the area in the foreground; all you want to do is darken the area in the distance. To fix the too-light areas, all you have to do is select the area to fix and then apply any of the techniques discussed in this chapter to the selected area.

Figure 8.10

Select an area to darken.

Select the Area to Fix

To select the area to fix, enter the Standard Edit mode and use the techniques you learned in Chapter 2, "How to Fix Only Part of a Picture." You can use the Marquee tools to select rectangular or elliptical areas or the Magic Wand or Lasso tools to select irregularly shaped areas. You should also use the Feather command to soften the edges of your selection. The result should look like that in Figure 8.10.

Quick Fixes

After you've selected the area you want to fix (in Standard Edit mode), you can switch to Quick Fix mode and apply any of the Lighting fixes to the selected area. Just follow the steps outlined earlier in this chapter; the effect will apply *only* to the selected area and leave the rest of your photo as-is—the perfect solution to fixing just part of a picture.

Fix It with Layers

If your background is really light and contains a lot of washed-out detail, your best solution is probably to use layers for that part of the picture. You have to create a new layer based on the selected area and then make adjustments to that layer.

To apply this technique, you have to be in Standard Edit mode. Here's what to do:

1. After you select the area to edit, select **Layer** > **New** > **Layer Via Copy** to create a new layer from the selected area.

2. Open the **Layers** palette; the new layer (consisting of only the selected area) should be highlighted, as shown in Figure 8.11.

3. Now you can use the Blending Mode and Opacity controls on this new layer. First, pull down the **Blending Mode** control and select **Multiply**. Next, click the **Opacity** control (it should be set at 100% to start) to display the slider; drag the slider to the left for less effect or to the right for greater effect.

The result? That washed-out background gets a lot darker, without affecting the foreground area.

TIP

If the selected area is particularly light, you can duplicate the new layer to apply multiple darker layers, as discussed previously.

Figure 8.11

A new layer created from the selected area.

A brightness-corrected background behind the untouched original foreground.

Paint It Darker with the Burn Tool

If you need to darken only a small area of a photo, there's one more tool you might want to try. Elements's Burn tool, found in the Standard Edit mode, lets you paint a light area darker, using your cursor. Here's how it works:

1. From the Toolbox, select the **Burn** tool, as shown in Figure 8.12. (Right-click the **Sponge** tool button; then select **Burn Tool** from the menu.)
2. In the **Options** bar, shown in Figure 8.13, select a medium-sized soft-edged brush; pull down the **Range** menu and select **Highlights**; then set the **Exposure** control to **25%** or less.

3. Position the cursor over the area you want to darken.
4. Click and hold the mouse button and drag the cursor over the area, as shown in Figure 8.14. Continue to repaint over an area to darken it even more.
5. Release the mouse button when you're done.

I like the Burn tool—more than the Dodge tool, to be frank. When configured with a low Exposure setting, I find it can bring out subtle detail in an otherwise washed-out area.

The Burn tool is pretty much the mirror opposite of the Dodge tool, discussed in Chapter 7.

Figure 8.12

Select the Burn tool.

Figure 8.13

Select the appropriate options for the Burn tool.

Figure 8.14

Darkening an area with the Burn tool.

TIP

The key to success with the Burn tool is the amount of Exposure you select. In most cases, an Exposure level of 25% or less generates the best results.

How to Avoid Taking Light Pictures

To avoid letting too much light into your photos, keep a close eye on what you see through the camera's viewfinder. You'll generally be able to see whether a picture is going to be overexposed and have time to make corrections.

The first thing to do is to move your subject away from the light, just a bit. You can also try reactivating your camera's auto focus feature, which also recalibrates the camera's exposure setting. And definitely watch out for strong backlighting behind your subject; avoid shooting people directly in front of open windows and other strong light sources.

With many cameras, you can also adjust the exposure setting manually. Read your camera's instruction manual to see how this works; if you decrease the exposure, you create a darker picture.

FIXING BAD COLOR

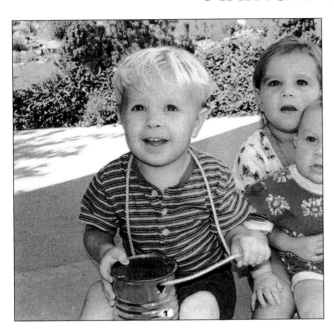

Before

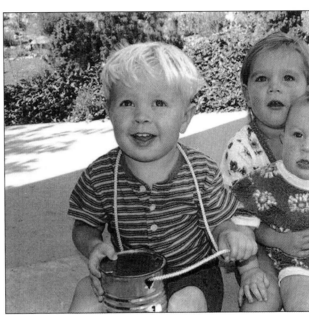

After

It's often difficult to get the colors to come out right in your photos. You take what you think is a great picture, only to discover that the deep blue sky came out a washed-out light blue, or that a soft red blouse ended up blooming bright red, or that everything in the picture was colored with a sickly green tint.

Yuck!

"It's often difficult to get the colors to come out right in your photos."

In most cases, bad color is the result of lighting conditions. Too little light screws up color rendition tremendously, and different types of indoor lighting impart all manner of unwanted casts on what you shoot. The solution, of course, is to use Photoshop Elements to correct the bad color—which it does with remarkable proficiency.

Auto Color Correction

Shoot indoors without a flash and you stand a good chance of capturing wildly inaccurate colors. The problem is so prevalent that I make it a point to color correct all my indoor shots, just to be safe.

You can also run into color problems with outdoor shots, depending on the time of day you shoot (sunlight is different colors at different times of the day) and other factors, such as the amount of shade and the color reflected from nearby objects. The picture here is an example of an off-color outdoors shot; notice the greenish cast to the entire picture, in part reflecting the surrounding greenery.

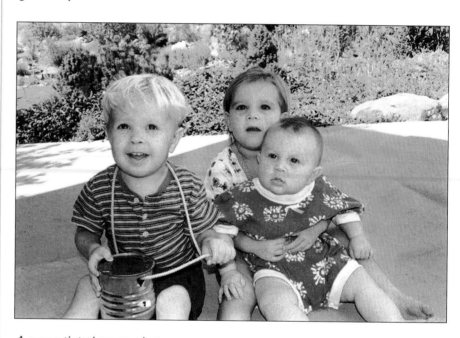

A green-tinted group photo.

NOTE

Hue refers to the color cast of a picture—whether it's greenish or reddish or blueish. *Saturation* refers to the amount of color—whether it looks pale (undersaturated) or has too much color (oversaturated).

You might think that fixing a picture this far off color would require breaking out an entire palette of color tools. Well, even though Elements has an entire array of tools you can use (and that we'll get to shortly), most color fixes can be done in a single operation using the Auto Color command. Here's all you have to do:

1. Click the **Quick Fix** button to enter the Quick Fix mode.
2. Go to the Color section and click the **Auto** button next to the Color label, as shown in Figure 9.1.

Yep, that's it. One click of a button and Elements sets about fixing the hue and color saturation of your picture. In many instances, this is the only fix you need to do.

Figure 9.1

Click the Auto Color button.

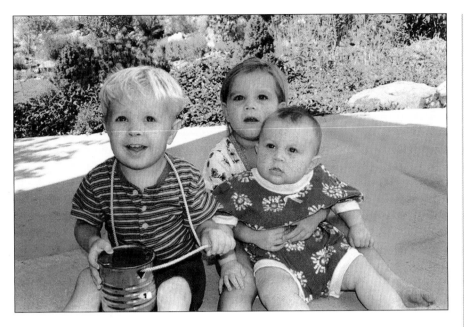

Our original picture, after applying the Auto Color Correction command.

Remove the Color Cast

Try This Instead

If all that's wrong with your picture is that it has an undesirable color cast—that is, if the hue is off across the entire picture, but the saturation level is okay—then Elements offers another method that might do a slightly better job than the Auto Color command. The Remove Color Cast command lets you specify neutral color areas of your picture (that is, areas that should be plain white, black, or gray) and uses that information to remove any undesired color cast.

Figure 9.2

Getting ready to remove an undesired color cast.

You can access the Remove Color Cast command from either the Quick Fix or Standard Edit mode. Follow these steps:

1. Select **Enhance** > **Adjust Color** > **Remove Color Cast** to open the Remove Color Cast dialog box, shown in Figure 9.2.

2. Position your cursor over a spot in your picture that should be a neutral black, white, or gray; the cursor changes to an eyedropper shape, as shown in Figure 9.3.

3. Click the neutral spot; the image changes color based on your selection.

4. If you're not satisfied with this change, click a different neutral spot. Repeat until you achieve the correct overall color cast.

5. Click **OK** to close the dialog box when you're done.

Figure 9.3

Click a neutral black, white, or gray spot.

The difficulty in using the Remove Color Cast command is finding a true white, black, or gray area—one that should be completely devoid of color. If you click the wrong spot, it's all too easy to end up creating a worse color cast than what you started with! Also, you have to remember that the Remove Color Cast command affects only the picture's hue; it doesn't affect the color saturation of the picture.

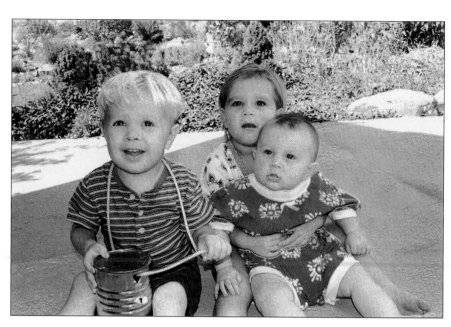

The original picture, after applying the Color Cast command.

Try This Instead

Choose Different Color Variations

Fixing color is an involved procedure, as you can see, and the Auto Color and Remove Color Cast commands don't always get it right. When the automatic solutions don't work, it's time to try something a little more complex—Elements's Color Variations command.

The Color Variations command doesn't guess at how your picture should look; instead, it offers you a preview of several different fixes and lets you pick which solution looks best to you.

You can access the Color Variations command from either Quick Fix or Standard Edit mode. Here's how it works:

1. Select **Enhance** > **Adjust Color** > **Color Variations** to open the Color Variations dialog box, shown in Figure 9.4.

2. To adjust the dark areas of your picture, select the **Shadows** option; to adjust the mid-gray levels of your picture, select the

TIP

The two thumbnails at the top of the dialog box display your picture before and after the selected fix.

Midtones option; to adjust the light areas of your picture, select the **Highlights** option.

3. Select the amount of change you want to make by adjusting the **Amount** slider to the left (less effect) or right (more effect).

4. Select one of the eight adjustment options: Increase Red, Increase Green, Increase Blue, Decrease Red, Decrease Green, Decrease Blue, Lighten, or Darken. You have to pick the one that looks best to you.

5. Select the **Saturation** option (shown in Figure 9.5), adjust the **Amount** slider to the left (for less effect) or to the right (for more effect), and then select either **Less Saturation** or **More Saturation**.

6. When you're finished making adjustments, click the **OK** button.

Not a lot of work, and the results are much more fine-tuned to your particular tastes.

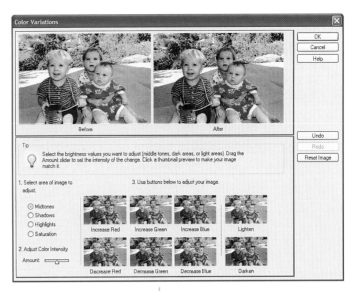

Figure 9.4

Adjusting color via the Color Variations dialog box.

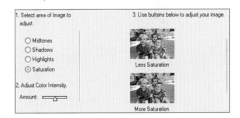

Figure 9.5

Adjusting color saturation.

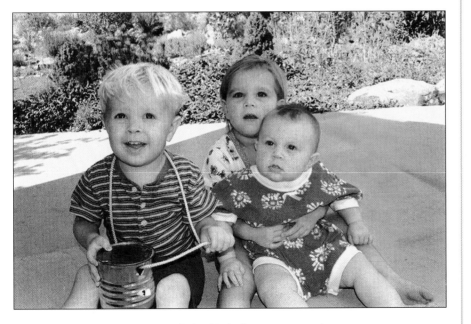

Our picture, adjusted via the Color Variations command.

Change the Hue and Saturation

Figure 9.6

Adjusting the Quick Fix Color controls.

Each time you make a selection, all the options are updated; you can make additional selections in this fashion.

When you try the previous solutions and the colors are still "off" in your picture, you need to roll up your sleeves and get your hands dirty. That's right, it's time to use Elements's manual Hue and Saturation controls, which you can do from Quick Fix mode.

Here's how to do it:

1. Click the **Quick Fix** button to enter the Quick Fix mode.

2. Go to the **Color** section, shown in Figure 9.6.

3. To increase the color level of your picture, drag the **Saturation** slider to the right; to decrease the amount of color, drag the slider to the left.

4. To change the overall color cast of the picture, adjust the **Hue** slider.

5. To make the picture warmer (more reddish), move the **Temperature** slider to the right; to make the picture cooler (more blueish), move the slider to the left.

6. To give the picture more of a magenta cast, move the **Tint** slider to the right; to give the picture more of a greenish cast, move the slider to the left.

Remember, these controls affect all the colors in your picture. A little adjustment can have a big impact.

Adjust the Color Manually

Elements offers even more precise color adjustment from the Hue/Saturation dialog box, which you can access from either the Standard Edit or Quick Fix mode. This dialog box duplicates the Hue and Saturation controls in the Quick Fix workspace and adds even more functionality, including the ability to adjust the lightness of the color and the ability to adjust just one color at a time.

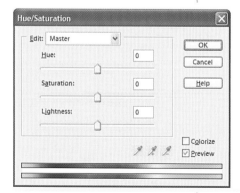

Figure 9.7

Adjusting color hue and saturation manually.

This method is recommended only if you have a good eye for color and a sure hand on the mouse. If you think you're up to the task, here's how it works:

1. Select **Enhance** > **Adjust Color** > **Adjust Hue/Saturation** to open the Hue/Saturation dialog box, shown in Figure 9.7.

2. To adjust all the colors in your picture at once, like you did with the Quick Fix Color controls, pull down the **Edit** menu and select **Master**. (You can also adjust each color individually—which we'll get to in a moment.)

3. Start by adjusting the saturation of color in your photo. Drag the **Saturation** slider to the left to reduce the overall color level or to the right to increase the color level.

4. If your picture is too dark or too light, drag the **Lightness** slider to the left (darker) or right (lighter).

5. Now let's work on the picture's tint or color cast. Drag the **Hue** slider to the left to make the color more red, then purple, then blue; or to the right to make the color more yellow, then green, then blue.

6. If your picture needs more or less of a particular color, pull down the **Edit** menu, select the color, and then adjust the **Saturation** slider accordingly. For example, to add more red to your picture, pull down the **Edit** menu and select **Red**, and then drag the **Saturation** slider to the right until the red level increases to your tastes.

7. When you're satisfied with the results, click **OK**.

This method, although the most involved, provides the most precise control over a picture's color. It's also a method that's easy to mess up; even the smallest adjustment can have major results!

NOTE

The two color bars at the bottom of the dialog box represent the colors in your picture before (top) and after (bottom) adjustments.

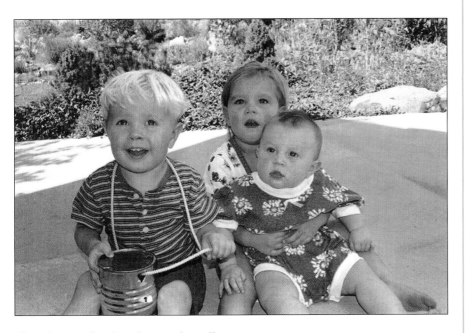

Our picture after hands-on color adjustment.

Fix the Color of Only Part of Your Picture

Specific Solutions

You don't have to change all the colors in your picture. Sometimes you need to fix only a specific area or an individual object. If this is the case, you need to mask off that area and then apply the appropriate color correction technique.

Correct Color for a Selected Area

To select the area to fix, enter the Standard Edit mode and use the techniques you learned in Chapter 2, "How to Fix Only Part of a Picture." You can use the Marquee tools to select rectangular or elliptical areas or the Magic Wand or Lasso tools to select irregularly shaped areas. You might also want to use the Feather command to soften the edges of your selection.

After you've selected the area you want to fix, you can then apply the Auto Color, Remove Color Cast, Color Variations, or manual Hue/Saturation operations to the selected area. Just follow the steps outlined earlier in this chapter; the effect will apply *only* to the selected area and leave the color in the rest of your photo as-is.

Brightly colored playground equipment—except for the faded yellow bars.

Here's a good example. The yellow bars on this jungle gym look faded compared to the other bright colors. (Yellow is a tough color to capture properly, especially in bright sunlight.) The fix is as simple as selecting all the yellow sections (in this instance, using the Magic Wand tool) and then using the Hue/Saturation control to increase the color saturation and decrease the lightness of the selected areas. As you can see in these before and after photos, only the color in the selected areas have changed; the rest of the picture retains its original color.

The same photo, after color correcting the yellow bars.

Change the Color Saturation for a Small Area

If you need to change only an area's color saturation and you don't want to go through all the bother of selecting an area to correct, you might want to consider using Elements's Sponge tool. Alas, this is another tool where the name gives no indication as to what the tool actually does. In this case, the Sponge tool lets you "sponge up" excess color—or, in its inverse mode, increase color saturation—just by painting over an area.

For example, the flower in this photo is a little too vivid for my taste. We don't want or need to correct the color in the entire picture (the green leaves look just fine), so it's time to put the Sponge tool to work.

Only the flower petals in this photo need correcting.

Figure 9.8

Select the Sponge Tool.

Figure 9.9

Configure the options for the Sponge tool.

Figure 9.10

Painting a new saturation level over your picture.

Here's how it works:

1. Click the **Standard Edit** button to enter the Standard Edit mode.
2. From the Toolbox, select the **Sponge** tool, shown in Figure 9.8.
3. In the Options bar, shown in Figure 9.9, pick a medium-sized soft-edged brush; pull down the **Mode** menu and select **Desaturate**; and set the **Flow** control to **25%**.
4. Position the cursor over the area you want to change.
5. Click and hold the mouse button and drag the cursor over the area, as shown in Figure 9.10. Continue to repaint over an area to further change the saturation.
6. Release the mouse button when you're done.

Our photo with the flower petals toned down a tad.

The affect of the Sponge tool is somewhat subtle, so it's not the best choice if you need to make really big changes. But I like the way it can slightly increase the vividness of a color or tone down somewhat too-colorful areas. It's a useful tool to have in your kit.

How to Avoid Taking Pictures with Poor Color

The light you shoot under has tremendous impact on the colors captured in a photo. Generally, the best conditions for color rendition are shooting outdoors on a sunny day. (Although shooting in too bright a light can result in washed-out, less-vivid colors.) Shooting indoors under low or artificial light is what causes most color problems.

There are two reasons for that. First, artificial lighting, while appearing "white" to our eyes, actually has a distinct cast caused by the *color temperature* of the light source. Incandescent lighting has an orange cast; fluorescent lighting has a green cast.

Second, low lighting levels play havoc with your camera's digital color imaging. If the light is too low, you often end up with oversaturated colors. (That's why professional photographers have all those lights around; the more light, the more accurate the color reproduction.)

To solve the first problem, many digital cameras have an automatic white balance control that, in most cases, compensates for lighting variations. Some cameras also have a manual white balance control you can set for various types of indoor lighting.

To solve the second problem, all you have to do is use more light. That might mean shooting outdoors instead of indoors, opening up a few more windows or doors, using your camera's built-in flash, or investing in some photo flood lamps. In any case, the more (and better) light you can pour into your picture, the more accurate your colors will be.

TIP

Another way to compensate for different types of lighting is to use a color filter on your camera lens. For example, a blue filter corrects for an orange cast. Also good is a polarizing filter, which reduces glare from reflective surfaces and produces more intense colors.

FIXING SOFT AND BLURRY PICTURES

Before

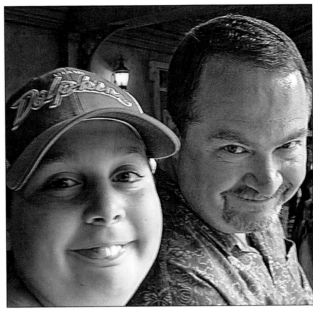

After

"Even with the best digital camera, really sharp pictures are sometimes difficult to take"

Even with the best digital camera, really sharp pictures are sometimes difficult to take. Unless you use a tripod, it's easy to jiggle the camera when you press the shutter button. Shooting indoors, under low light, only makes it worse; the long exposures necessary accentuate every little bit of camera shake. And let's not even get into how hard it is to shoot a moving object!

Then there's the problem of focus. Your camera probably has an auto focus feature, but even the best auto focus sometimes gets confused and focuses a little in front of or behind the main subject. And if you're focusing manually…well, blurry, out-of-focus pictures are the bane of even the most diligent photographers.

Before the age of digital photography, if you had a soft or blurry picture, you pretty much had to throw it out. That's not the case any more, fortunately, because we have all sorts of digital wizardry at our disposal to focus in on those blurry edges.

Subtle Sharpening with Auto Sharpen

Whether the cause is a moving subject, a shaky camera, or just poor focus, Elements offers several ways to sharpen a blurry picture. Take the photo seen here, in which a combination of autofocus problems and a moving subject result in the background being in sharp focus while my nephew Ben and I are slightly out of focus—Ben especially so. (He was the one who leaned forward just as the shot was taken.) It would be a shame to throw this picture away, when we might be able to digitally sharpen it to an acceptable level.

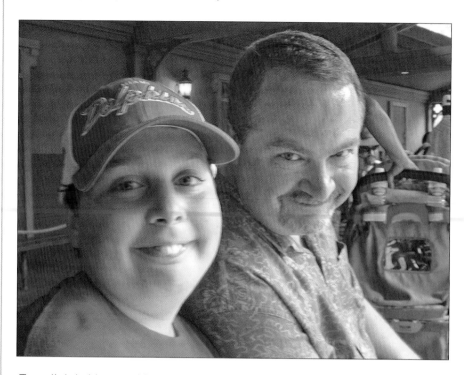

Two slightly blurry subjects against a sharp background.

As always, you should try the simplest solution first. Among its many Quick Fix operations, Elements offers an Auto Sharpen feature. Like most of Elements's sharpening options, Auto Sharpen works by boosting the contrast between adjacent pixels in the picture; the result is an increase in the apparent sharpness.

Figure 10.1

Sharpening a photo with the Auto button next to the Sharpen label.

Here's how to do it:

1. Click the **Quick Fix** button to enter the Quick Fix mode.
2. Go to the Sharpen section and click the **Auto** button next to the Sharpen label, as shown in Figure 10.1.

As you can see, Auto Sharpen provides a subtle sharpening effect. It works best when your picture is only slightly blurry.

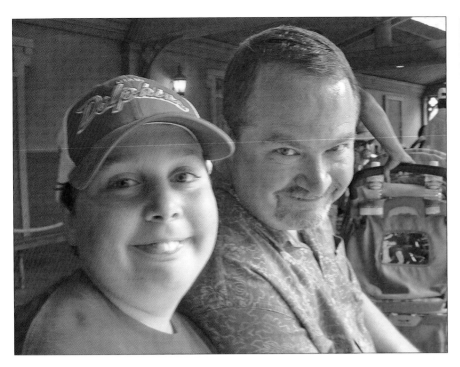

Our blurry subjects after applying the Auto Sharpen fix—a little better, but not perfect.

Control the Amount of Sharpening

If the Auto Sharpen operation didn't sharpen things enough, you can step up the effect by adjusting the Sharpen Amount slider in the Quick Fix workspace. This lets you control the amount of sharpening applied to your picture, from just a little to quite a bit.

Follow these steps:

1. Click the **Quick Fix** button to enter the Quick Fix mode.
2. Go to the **Sharpen** section.
3. Drag the **Amount** slider to the right until the desired sharpness level is achieved, as shown in Figure 10.2.

This Quick Fix adjustment works surprisingly well. The only problem is that, if you sharpen the picture too much, you introduce some degree of graininess to the picture. The solution is to move the slider to the right until it's just a tad too grainy and then back it off a touch.

Try This Instead

Figure 10.2

Drag the Amount slider to adjust the amount of sharpening.

Our picture with more sharpening applied, via the Sharpen Amount slider.

Try This Instead

Create Sharper Edges with the Unsharp Mask Filter

The first two fixes in this chapter were relatively easy; the rest of the fixes are a bit more complicated. So, if your picture is still blurry or the other techniques introduced too much noise, it's time to apply some digital elbow grease.

The sharpening technique most used by professional photographers is Elements's Unsharp Mask filter. Even though the name says "unsharp," the filter is actually used to sharpen the appearance of soft or blurry images. The Unsharp Mask filter works by adding light and dark lines on each side of an edge; this emphasizes the object's edges, creating the appearance of sharpness. It can be used to sharpen blurry pictures or to make hard edges even harder.

The reason I didn't recommend the Unsharp Mask filter sooner is that it's not a one-button technique; it actually requires a bit of user judgment to achieve the best results. In other words, this is a technique that lets you tweak the correction effect. The quality of the fix depends on the choices you make.

You can apply the Unsharp Mask filter from either the Quick Fix or Standard Edit mode. Here's how it works:

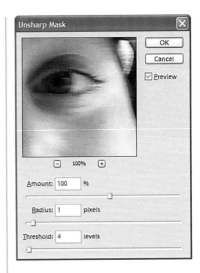

1. Select **Filter** > **Sharpen** > **Unsharp Mask** to open the Unsharp Mask dialog box, shown in Figure 10.3.

2. Drag the **Amount** slider (or enter a value in the **Amount** field) to determine how much to increase the contrast of the picture's individual picture elements (called *pixels*). In general, 100% is a good level for smaller or lower-resolution pictures; 150% is good for larger or higher-resolution pictures.

3. Drag the **Threshold** slider (or enter a value in the **Threshold** field) to determine the threshold of the effect. The lower the number, the greater the sharpening effect.

4. Drag the **Radius** slider (or enter a value in the **Radius** field) to determine the number of pixels to sharpen around edges. A lower value sharpens only the edge pixels, whereas a higher number sharpens a wider band of pixels around the edge of the object.

5. Click **OK** to apply the filter.

Figure 10.3

Use the Unsharp Mask filter to apply quality sharpening effects.

Our two guys, nicely sharpened with the Unsharp Mask filter.

The reason you want to set the Radius last, even though it's the middle of the three controls, is because you can use it to "eye" your results. That is, the best way to set the Radius value is to adjust the slider until you like what you see.

NOTE

The results of your adjustments are shown immediately in the preview area of the Unsharp Mask dialog box, and in your original picture.

TIP

The embossed layer technique is especially useful for sharpening objects with a lot of hard edges.

That said, I've found some general settings that work best with specific types of pictures. You can use the settings in Table 10.1 as a starting point when working with the Unsharp Mask filter.

Table 10.1 Unsharp Mask Filter Settings Guide

Type of Picture	Amount	Radius	Threshold
General	100%	1	4
Portraits	75%	2	3
Objects with naturally soft edges	150%	1	10
Objects with naturally hard or well-defined edges	200%	3	0
Blurry pictures	75%	4	3
Badly out-of-focus pictures	400%	0.1	0

Most users never even get to the Unsharp Mask level, which is a shame. Although Elements's Quick Fix sharpening operations do an okay job, the Unsharp Mask filter produces results you wouldn't think you could obtain from even seriously out-of-focus photos.

Last Resort

Artificially Enhance Edges with an Embossed Layer

Even the Unsharp Mask, however, can introduce some noise and grain into your pictures. If this bothers you, there's one more technique to consider that uses Elements's Layers feature. This last technique is one that won't work in all instances, but when it does, it creates a picture with very defined edges and a minimum of extraneous noise elsewhere in the picture.

The interesting thing about this technique is that it doesn't use any of Elements's sharpening filters. Instead, it creates a copy of the background layer and then embosses it—that is, it "raises" the edges of objects. When you overlay the embossed layer on the original photo, all the edges get sharper—without adding the typical sharpening noise.

Here's what you do:

1. Click the **Standard Edit** button to enter the Standard Edit mode.
2. Duplicate the background layer by selecting **Layer** > **New** > **Layer via Copy**.
3. Select the **Layers** tab in the Palette Bin and select the new layer (**Layer 1**), as shown in Figure 10.4.

Figure 10.4

Select the new layer.

4. Select **Filter** > **Stylize** > **Emboss** to open the Emboss dialog box, shown in Figure 10.5.

5. Enter the following settings into the Emboss dialog box: **Angle: 135 degrees**; **Height: 15 pixels**; **Amount: 65%**.

6. Click **OK** to close the dialog box and apply the embossing; the selected layer now looks like Figure 10.6.

7. Go to the **Layers** palette and make sure Layer 1 is still selected; then change the blending mode from **Normal** to **Hard Light**.

8. Still in the Layers palette, use the **Opacity** control to adjust the amount of the sharpening effect. A lower Opacity level produces a more subtle effect; a higher Opacity level produces harder edges around objects.

That's it. Make sure you play around with the opacity of the embossed layer; the higher the opacity level, the greater the sharpening. This method is a bit more involved than any of the sharpening filters, but it does a good job on pictures with well-defined edges—without introducing any graininess.

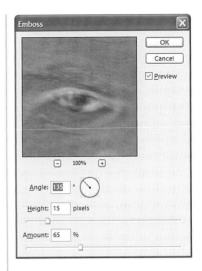

Figure 10.5

Apply the Emboss filter to the new layer.

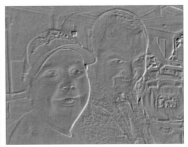

Figure 10.6

The results of the Emboss filter.

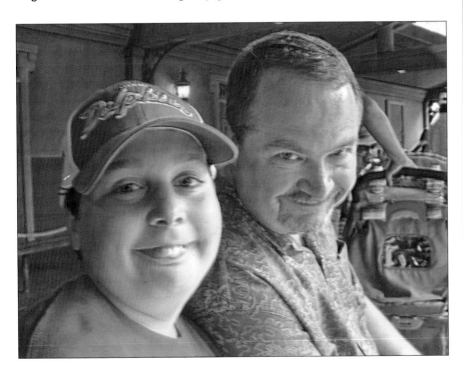

Our picture sharpened with an embossed layer.

Specific Solutions

Sharpen Just Part of a Picture

What if you want to sharpen only part of a picture? For example, you might want to sharpen a foreground object, while leaving the background a little blurry, for effect.

Sharpen a Selected Area

Naturally, you can apply sharpening effects to a specific area by first selecting the area and then applying any of the sharpening methods discussed earlier in this chapter. You can also use this technique to sharpen a particular object in your picture.

However, when you're sharpening a defined object, you probably don't want to select an object and then sharpen the selected object because you'll end up with unnaturally sharp edges against the softer background. Instead, try selecting a larger area around the object and then sharpening the entire area. If you take this approach, be sure you apply heavy feathering to the selection to better blend with the nonselected background.

Use the Sharpen Tool

A better approach might be to "paint" your sharpening by using Elements's Sharpen tool. This tool works just like a paint brush; when you drag the Sharpen tool over a part of your picture, that area gets sharper.

Here's how to use the Sharpen tool:

1. Click the **Standard Edit** button to enter the Standard Edit mode.
2. From the Toolbox, select the **Sharpen** tool, shown in Figure 10.7. (Right-click the **Blur** tool button, and then select **Sharpen Tool** from the menu.)

Figure 10.7

Select the Sharpen tool.

Figure 10.8

Configure the options for the Sharpen tool.

3. In the Options bar, shown in Figure 10.8, select a medium-sized, soft-edged brush. Then make sure the **Mode** is set to **Normal** and the **Strength** is set to **50%**.
4. Position the cursor over the area you want to sharpen.
5. Click and hold the mouse button and drag the cursor over the area, as shown in Figure 10.9; continue to paint over the area you want to sharpen until you achieve the desired sharpening effect.
6. Release the mouse button when you're done.

Figure 10.9

Painting an area sharper.

If you oversharpen an area, press **Ctrl+Z** (Mac: ⌘-**Z**) to undo your latest changes.

NOTE

Learn more about selecting and feathering an area or object in Chapter 2, "How to Fix Only Part of a Picture."

How to Avoid Taking Blurry Pictures

There are several ways you can reduce the number of blurry pictures you take.

First, avoid shooting in low light. Most blurry pictures result from shaky cameras, and camera shake is more pronounced when you're shooting the type of long exposures necessary in low-light situations. Increase the light (or use a flash) and you'll shoot shorter exposures, with less chance of camera shake.

If you must shoot in low light, use a tripod. Nothing holds a camera still better than a quality tripod. Alternately, if you have one, operate your camera with a remote shutter release. This eliminates any camera shake resulting from manually depressing the shutter button.

You should also pay careful attention to your focusing. If you're using your camera's auto focus feature, make sure you're using it properly. Read the camera's instruction manual to better understand how the auto focus works, and under what situations it can be tricked into improperly focusing.

If you're focusing manually, the only advice I have is to try to be more careful. I know how difficult it is to "eyeball" the correct focus, especially under low light. Still, if you choose to focus manually, it's up to you to get the focus right.

Finally, if you're shooting a rapidly moving subject, switch to your camera's preprogrammed "sports" mode (if it has one) or manually select a shorter exposure. You want the camera's lens open for as short a period as possible, to better freeze the action. Again, the better the lighting, the easier it will be to capture action quickly.

FIXING GRAINY PICTURES

Before

After

"Some people like a slight grainy effect (it looks like you're shooting on old film stock), but if you'd rather have a noiseless picture, you can use Photoshop Elements to soften or remove the grain and noise from your photo."

If you shoot photos under strong light, you'll probably never shoot a grainy picture with your digital camera. But if you like shooting indoors or under other low-light conditions, you'll sometimes end up with a picture that looks grainy, with all sorts of "noise" in the background. Some people like a slight grainy effect (it looks like you're shooting on old film stock), but if you'd rather have a noiseless picture, you can use Photoshop Elements to soften or remove the grain and noise from your photo.

Remove Graininess with the Despeckle Filter

Here's the type of picture I'm talking about. It was taken outdoors at night, with nothing but a flash and a porch light, which didn't make things near bright enough. Just look at all the noise and graininess throughout the picture—how can we clean this up?

A very grainy picture, taken in low light.

The first thing to try is Elements's Despeckle filter. As the name implies, this filter removes the "speckles" from your photos by blurring all of the photo except the hard edges around objects. So, even though the graininess is blurred out, the objects you shoot remain distinct.

You can apply the Despeckle filter from either the Quick Fix or Standard Edit mode. It's basically a one-step operation:

1. Select **Filter** > **Noise** > **Despeckle**.

The results are sometimes quite satisfactory; sometimes the effect is so subtle as to be virtually unnoticeable. In the best of conditions, the edges of objects remain sharp, while the grain is minimized.

Our grainy picture, slightly despeckled.

Blur the Grain Away with the Blur Filter

Try This Instead

If you're working with a very grainy picture, you might need a stronger solution than that provided by the Despeckle filter. You should instead try Elements's Blur filter. This filter smoothes transitions between different colors by averaging the color values of the pixels. The result is a softer image, overall, which blurs out the graininess.

This filter can also be applied from either the Quick Fix or Standard Edit mode. Here's what you do:

1. Select **Filter** > **Blur** > **Blur**.

The Blur filter creates a softer overall image than does the Despeckle filter. If you have a lot of grain in your picture, this can be the way to go.

Our grainy picture, after applying the Blur filter.

Apply Heavier Blurring with the Blur More Filter

TIP

If the Blur filter didn't get rid of all the graininess, try the Blur More filter instead. This filter is several times stronger than the regular Blur filter.

This is one of those filters where a little change makes a big impact. Seldom will you want to apply more than a 4- or 5-pixel blur; in most instances, a setting of 1 or 2 pixels will be plenty to soften the noise in your picture.

You can use the Blur More filter from either the Standard Edit or Quick Fix mode. Here's how it works:

1. Select **Filter** > **Blur** > **Blur More**.

You can even apply the Blur More filter after you've applied the Blur filter, for a super-duper blurring effect.

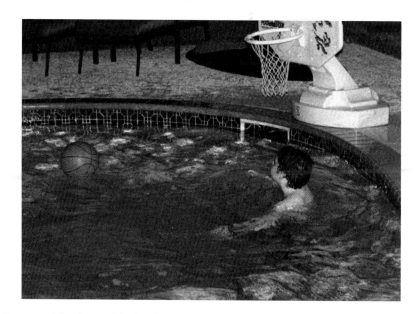

Stronger blurring, with the Blur More filter.

Figure 11.1

Softening the grain with the Median filter.

Even More Blurring with the Median Filter

For a slightly different blur effect, try Elements's Median filter. The way this filter works is a little complicated: It averages out the brightness of the pixels in the picture, on the theory that noise or grain is a lot brighter (or darker) than the surrounding picture.

The effect is a stronger overall blurring but with a much softer picture overall. Like the other filters, you can apply the Median filter from either the Quick Fix or Standard Edit mode.

To use the Median filter, follow these steps:

1. Select **Filter** > **Noise** > **Median** to open the Median dialog box, shown in Figure 11.1.

2. Move the **Radius** slider to the right to increase the blurring effect or to the left to minimize the effect. View the results

in the dialog box preview, or (with the **Preview** option selected) in your main picture.

3. Click **OK** to apply the filter.

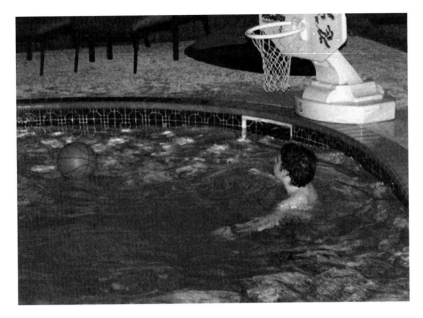

Our grainy picture, softened with the Median filter.

Fine-tune Grain Removal with the Dust & Scratches Filter

The main problem with the Median filter is that it's a brute-force approach to the graininess problem. If you want finer control over the pixel-changing effect, try Elements's Dust & Scratches filter. It works similarly to the Median filter but lets you achieve a better balance between softening the grain and maintaining some degree of picture sharpness.

Apply the Dust & Scratches filter from either the Quick Fix or Standard Edit mode. Here's how it works:

1. Select **Filter > Noise > Dust & Scratches** to open the Dust & Scratches dialog box, shown in Figure 11.2.

2. Drag the **Radius** slider to the right to increase the blurring effect or to the left to decrease the effect.

3. Drag the **Threshold** slider to the right until the grain becomes noticeable again; then back off slightly.

4. Click **OK** to apply the filter.

The result should be a more subtle softening than achieved with the Median filter.

Try This Instead

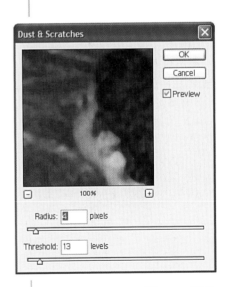

Figure 11.2

Fine-tuning the softening effect with the Dust & Scratches filter.

A more subtle softening with the Dust & Scratches filter.

Remove Color Noise

In some instances, the graininess in a picture is digital noise, in the form of color speckles. Softening or blurring the picture won't solve this problem; instead, you need to remove the color from the speckles.

A picture with a lot of color speckles—otherwise known as digital noise.

The solution to this problem is rather involved, requiring the manipulation of Elements's layers, so follow along carefully:

1. Click the **Standard Edit** button to enter the Standard Edit mode.

2. Start by copying the picture's Background layer by selecting **Layer** > **Duplicate Layer**. When the Duplicate Layer dialog box appears, as shown in Figure 11.3, accept the default name (**Background copy**) and click **OK**.

3. Select the **Layers** tab in the Palette Bin, as shown in Figure 11.4. Select the new layer, which should be labeled Background copy.

4. Select **Filter** > **Blur** > **Gaussian Blur** to open the Gaussian Blur dialog box, shown in Figure 11.5.

5. Drag the **Radius** slider to the right until all the color noise is blurred from the picture; then click **OK**.

6. Return to the Layers palette and change the blending mode from Normal to **Color**.

This should result in the removal of the color speckles, while still retaining the picture's sharpness. If some graininess remains after applying this technique (which it might), use one of the techniques covered previously to soften the remaining grain.

Figure 11.3

Create a copy of the background layer.

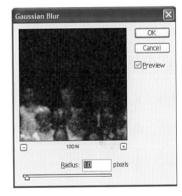

Figure 11.4

Select the Background copy layer.

Digital noise removed—no more color speckles!

Figure 11.5

Apply the Gaussian Blur filter to the new layer.

TIP

Specific Solutions

Soften Only Part of a Picture

If you have a grainy picture, chances are the graininess is worse in the dark areas of the picture. In fact, you might not need to soften or despeckle the entire picture; you might only need to fix the dark areas.

When you're working on just part of the picture, you might be able to apply a stronger blur effect than you would if working with the entire picture.

Soften a Selected Area

To fix only part of a picture, use the techniques discussed in Chapter 2, "How to Fix Only Part of a Picture," to select the area you want to work on. Then apply any of the filters presented earlier in this chapter to the selection.

Use the Blur Tool

Figure 11.6

Select the Blur tool.

Another option to soften a specific area is to use Elements's Blur tool. You can use the Blur tool to paint parts of your picture softer.

Here's how to paint with the Blur tool:

1. Click the **Standard Edit** button to enter the Standard Edit mode.
2. From the Toolbox, select the **Blur** tool, shown in Figure 11.6.
3. In the Options bar, shown in Figure 11.7, select an appropriately sized soft-edged brush. Pull down the **Mode** menu and select **Normal**; then set the **Strength** to **50%**.

Figure 11.7

Configure the options for the Blur tool.

4. Position the cursor over the area you want to blur.
5. Click and hold the mouse button while dragging the cursor over the area, as shown in Figure 11.8; continue to paint over the area you want to blur until you achieve the desired effect.
6. Release the mouse button when you're done.

How to Avoid Taking Grainy Pictures

In most instances, you can eliminate graininess in your photos by shooting with adequate lighting. Especially avoid shooting indoors under extremely low lighting; if you must shoot indoors, turn on some light—or use your camera's flash!

Figure 11.8

Painting an area softer.

HOW TO FIX OTHERWISE PERFECT PICTURES OF IMPERFECT PEOPLE

ELIMINATING RED EYE

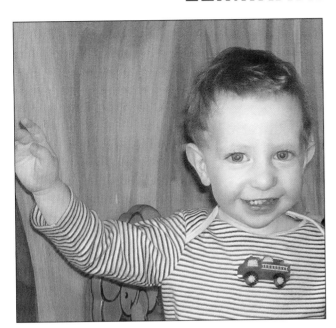

Before

After

"Unless your friends or family members actually have glowing red eyes, you need to eliminate the effect to achieve a realistic photo"

Probably the most common problem for digital photographers is the red eye effect. You know what I'm talking about: You shoot with a flash, and your subjects end up with glowing red eyes. Unless your friends or family members actually have glowing red eyes (in which case you have bigger problems than just a bad picture), you need to eliminate the effect to achieve a realistic photo.

TIP

Recolor Red Eye with Red Eye Removal Tool

Because red eye is such a common problem, Photoshop Elements makes it easy to fix. The program includes a special tool just for fixing red eye, called the Red Eye Removal tool. It's a fix so easy that just about anyone can do it.

If the one-click approach doesn't remove all the red eye, there's another technique you can use. With the Red Eye Removal tool selected, click and drag the cursor to draw a rectangle over the entire red area of the eye. When you release the mouse button, all the red should be gone.

Figure 12.1

Select the Zoom tool.

Figure 12.2

Zoom in on the eye.

Figure 12.3

Select the Red Eye Removal tool.

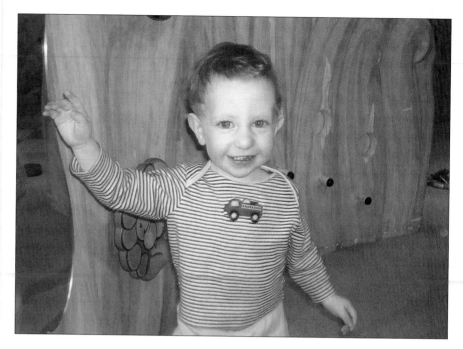

A devil baby—or a cute kid with a bad case of red eye?

The Red Eye Removal tool is accessible from either the Quick Fix or Standard Edit modes. All you have to do to get rid of the red eye is follow these steps:

1. Select the **Zoom** tool from the Toolbox, as shown in Figure 12.1.
2. Zoom in on the eye you want to fix, as shown in Figure 12.2, by clicking it once or twice with the Zoom tool.
3. Select the **Red Eye Removal** tool from the Toolbox, as shown in Figure 12.3.
4. Position the cursor over the red area of the pupil, as shown in Figure 12.4; then click once.
5. Repeat step 4 for each eye you need to fix.

It's a simple fix, and so effective that I don't need to present an alternative method. This one works!

That said, if for whatever reason the Red Eye Removal tool *doesn't* work on one of your pictures, there's another method you can use—the one normally used to fix the unique type of red eye found in pictures of animals. Read on to learn more.

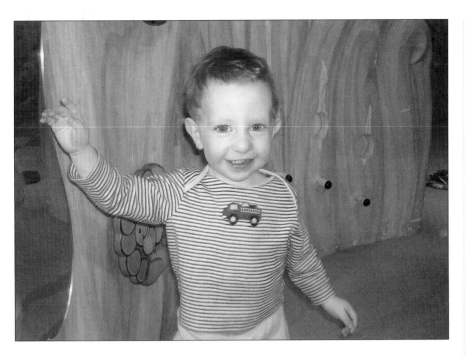

A happy baby—no more red eye!

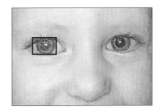

Figure 12.4

Click once to remove the red eye.

Fix Pets' Red Eye

Even worse than red eye on people is red eye on animals—which is often green or blue or yellow, not red. The reason you get more of this effect when you photograph your pets is because animals' eyes reflect more light than humans' eyes, which enhances their night vision. The result is a photographic problem that's much harder to fix—and that typically doesn't respond well to Elements's Red Eye Removal tool.

Specific Solutions

A demonic dog—or a bad case of "pet eye"?

NOTE

The new Red Eye Removal tool in Elements 3.0 is much more effective than the old Red Eye Brush tool in previous versions, which quite frankly didn't work all that well. If you're still using an older version of Elements, the new Red Eye Removal tool alone is worth the price of the upgrade!

Use the Red Eye Removal Tool

If your pet has a bad case of red eye—let's call it "pet eye"—the first thing to do is to try fixing it with Elements's Red Eye Removal tool, as described earlier in this chapter. Depending on the color of your pet's red eye, this might work—or it might not. If this doesn't do the trick, you need to use a more drastic technique—painting the eye.

Try This Instead

Paint the Pupil Black

Unfortunately, Elements's Red Eye Removal tool seldom does a good job fixing pet eye—especially when the color is something other than red. What you need to do, then, is paint your pet's pupils black.

Figure 12.5

Zoom in to the eye you want to fix.

Figure 12.6

Select the Lasso tool.

Figure 12.7

Set Feather to 1 pixel in the Options bar.

Figure 12.8

Draw a new pupil over the eye.

Figure 12.9

Select the Brush tool.

Here's how to do it:

1. Click the **Standard Edit** button to enter the Standard Edit mode.

2. Use the **Zoom** tool to zoom in to the eye you want to fix, as shown in Figure 12.5.

3. From the toolbar, select the **Lasso** tool, as shown in Figure 12.6. (Right-click the **Magnetic Lasso** tool, then select **Lasso Tool** from the menu.)

4. In the Options bar, set **Feather** to **1** pixel, as shown in Figure 12.7.

5. If the pupil of the eye is visible, use the **Lasso** tool to draw around the pupil, as shown in Figure 12.8. If the pupil of the eye isn't visible, draw an ellipse or a circle over the eye where the pupil should be.

6. From the toolbar, select the **Brush** tool, as shown in Figure 12.9.

7. Click the **Set Foreground Color** control in the toolbox. When the Color Picker dialog box appears (shown in Figure 12.10), select a black or similar dark color; then click **OK**.

8. From the Options bar, shown in Figure 12.11, pull down the **Brushes** list and select a suitable brush type. Set the **Size** control to a fairly large size, at least 10 pixels. Make sure that **Mode** is set to **Normal** and **Opacity** is set to **100%**.

9. Use the **Brush** tool to paint over the selected area, as shown in Figure 12.12. Don't worry about painting outside the lines; the color will automatically be confined to the area you drew in step 5.

10. Now you have a normal dark-eyed pet. To make the eye look completely natural, however, you might want to add some small white reflections in the center of the pupil. Keep the Brush tool selected, but click the **Set Foreground Color** control and, when the Color Picker appears (shown in Figure 12.13), change the foreground color to white. Then click **OK**.

11. Move back to the Options bar, shown in Figure 12.14, and enter a small number into the **Size** box. (The size of the brush you use depends on the size of the eye in the picture; you'll need to experiment with this on your own.) Leave all the other settings the same.

12. Click once where you want the highlight to appear, as shown in Figure 12.15.

Voilà! Your pet now has one artificial but natural-looking eye. Repeat this procedure for the other eye—and be sure to place the two highlights in the same relative position on each eye—and your pet no longer looks like a demon from hell!

Figure 12.10

Set the Brush color to black.

Figure 12.11

Set the Brush options.

Figure 12.12

Paint the eye black.

Figure 12.13

Change the Brush color to white.

Figure 12.14

Select a small-sized brush.

Figure 12.15

Paint a white highlight over the pupil.

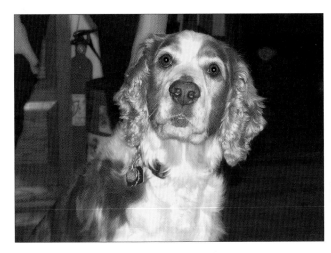

Nice doggy, with normal black eyes.

Interestingly, the color of the reflective layer in an animal's eyes—and thus the color of the "pet eye" effect—is somewhat dependent on the color of the animal's coat. For example, black dogs tend to have a green reflective layer, resulting in a vivid "green eye" effect; tan-colored dogs have a light blue reflective layer that creates "blue eye."

How to Avoid Red Eye

Whether we're talking humans or animals, red eye results from the light from a flash reflecting off the subject's retina; as a result, a trace (or more) of red appears in the eyes of the subject. The closer the flash is to the camera lens, the worse the effect because this shoots the light from the flash directly into the back of the subject's eyes.

The easiest way to avoid red eye is to not use your flash; you'll seldom get red eye when shooting under natural light. You can also minimize red eye by using more ambient light in addition to your flash.

The red eye effect can also be overcome by moving closer to your subject and positioning the camera a little off to the side. The more off-angle to the center of the eye you can get the flash, the less the effect.

Another solution is to use a different type of artificial lighting. If you're really into photographic gear, consider using a flash separate from your camera, bounce flash, or flood lights positioned off-angle to the subject. The goal is to light the subject without sending a beam of light directly into the back of her eyes.

Many digital cameras offer a red eye reduction feature, which fires a preflash red eye reduction light about a second before the normal flash. This forces the subject's pupils to contract, which lessens the amount of light reflecting off the back of the eye. Although this feature doesn't totally eliminate red eye, it does serve to minimize the effect.

GETTING RID OF CIRCLES UNDER THE EYES

Before

After

"... eye "bags" are generally unflattering and ripe for digital removal."

Dark circles under the eyes can make even a relatively young person look old and haggard. These circles can be a result of normal aging, a hard day (or night), or just bad lighting. (Harsh overhead lighting accentuates these dark circles.) In any case, eye "bags" are generally unflattering and ripe for digital removal.

Lighten the Circles with the Dodge Tool

As a good example of dark eye circles, let's work with a photo of a somewhat seamy looking gentleman. Well, actually, it's a picture of me, after a long hard day slaving away at the keyboard. It definitely looks like I need some sleep—or just some Elements magic!

When you take a picture of a person with circles under his eyes, those dark areas are just that—dark areas in the picture. And Photoshop Elements makes lightening just about any type of dark area relatively easy.

Figure 13.1

Select the Zoom tool.

Dark circles under the eyes make your subject look old and tired.

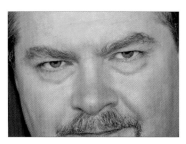

Figure 13.2

Zoom in on the area underneath the eye.

The first approach we'll take is to literally lighten the dark circles, using Elements's Dodge tool. You use the Dodge tool to "paint" the dark area with a lighter tone. Here's how you do it:

1. Click the **Standard Edit** button to enter the Standard Edit mode.

2. From the Toolbar, select the **Zoom** tool, as shown in Figure 13.1.

3. Click once or twice on the subject's eyes to zoom into the area you want to fix, as shown in Figure 13.2.

4. From the Toolbar, select the **Dodge** tool, as shown in Figure 13.3. (Right-click the **Sponge** tool button, then select **Dodge Tool** from the menu.)

5. From the **Options** bar, shown in Figure 13.4, select a relatively small, soft-edged brush; select **Midtones** from the **Range** list; and enter a value of **10%** into the **Exposure** box.

Figure 13.3

Select the Dodge tool.

6. Click and drag the cursor over the dark circle, working to brush the dark area away, as shown in Figure 13.5. It's okay to drag over an area several times to achieve the lightness you want.

Figure 13.4

Configure the Dodge tool.

When you've finished touching up the circles, zoom back out to normal size so you can judge your work in context. It's important not to lighten the circles too much; you don't want the area underneath the eye to end up lighter than the surrounding facial area!

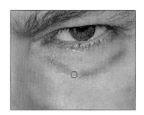

Figure 13.5

Brush away the dark circle.

Dark circles, lightened.

Replace Dark Skin with the Healing Brush Tool

Try This Instead

The only problem with the Dodge technique is that it only lightens the skin tone—it doesn't do anything about the folds or wrinkles that typically accompany dark circles. If you don't like the results you get with the Dodge tool, it's time to try a slightly more sophisticated technique, which involves replacing the undesirable circles with smoother, lighter flesh from elsewhere on the subject's face. You make this replacement with Elements's new Healing Brush tool.

Here's what you need to do:

1. Click the **Standard Edit** button to enter the Standard Edit mode.
2. From the Toolbar, select the **Zoom** tool.
3. Click once or twice on the subject's eyes to zoom into the area you want to fix.

Figure 13.6

Select the Healing Brush tool.

Figure 13.7

Configure the Healing Brush tool.

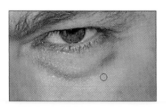

Figure 13.8

Select an area to clone.

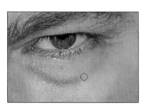

Figure 13.9

Painting the good area over the dark area.

4. From the Toolbar, select the **Healing Brush** tool, as shown in Figure 13.6. (Right-click the **Spot Healing Brush** button, then select **Healing Brush Tool** from the menu.)

5. From the **Options** bar, shown in Figure 13.7, select a small, soft-edged brush; pull down the **Mode** list and select **Lighten**; and make sure that the **Sampled** option is selected.

6. Now you need to select what area of the face you want to clone. Find an area of the face near the dark circle where the skin tone and color is what you'd consider normal or desirable, like that in Figure 13.8. Hold down **Alt** (Mac: **Option**) and click once in this area.

7. After you've selected the area to clone, you can start "healing" the dark circles. To do this, click and drag the cursor over the dark circle, as shown in Figure 13.9. As you drag over the area, the area you selected in step 6 will be "cloned" under the cursor. Note that the final effect isn't visible until you release the cursor; this is when Elements applies the "healing" effect that blends the newly cloned area into the surrounding area.

This technique works quite well. When you see how people look with their dark circles gone, you'll be using the Healing Brush tool to clone away the eye bags on all the portraits you take!

Dark circles, healed.

How to Avoid Shooting Circles Under the Eyes

If someone has dark circles under his eyes, there's not much you can do with the camera to get rid of them. You can, of course, advise your subjects not to party too hard the night before the shoot and to get plenty of sleep!

The most important thing you can do in this situation is to manipulate the lighting to minimize the effect. In particular, avoid harsh direct lighting. Try to position any available light a little lower and off to the side—*not* directly above the subject. And, if you can, diffuse the light by aiming it away from the subject or bouncing it off a piece of white paper or photo umbrella. Harsh light shining down on the subject creates shadows under the eyes, even if the subject doesn't have dark circles of his own!

TIP

In most photos, the area directly under the dark circle, on the upper cheek, is a good area to clone.

CAUTION

To avoid cloning an unexpected skin area over the dark circles, regularly resample the area to clone by repeating steps 6 and 7.

SOFTENING WRINKLES

Before

After

"Thanks to Photoshop Elements, digital wrinkle removal isn't limited to big Hollywood stars and professional glamour photography"

Ever wonder how those 40- and 50-something Hollywood stars keep looking so young? Well, part of it is makeup and part of it is plastic surgery, but a big factor in their eternal youthfulness is photo retouching. In other words, they really don't look that young in person; their youthfulness only comes through in their digitally retouched photos.

Thanks to Photoshop Elements, digital wrinkle removal isn't limited to big Hollywood stars and professional glamour photography. With the right tools and a little bit of work, you can remove the most obvious wrinkles from the people you shoot—and make them look years younger!

Heal Wrinkles with the Healing Brush Tool

We'll start with this photo of a thirtysomething brother and sister. The brother's face shows some slight signs of age, particularly in crows feet around the eyes. It makes him look older than he really is, but we can fix that.

The man in this picture has some age lines he'd like to remove.

Figure 14.1

Select the Zoom tool.

Figure 14.2

Zoom in on the wrinkled area.

Figure 14.3

Select the Healing Brush tool.

Elements 3.0 includes a new tool, called the Healing Brush tool, that is perfect for removing wrinkles. We first used this tool in the preceding chapter, to "heal" dark circles under the eyes, and it's just as effective with all manner of facial wrinkles. The Healing Brush tool works by "cloning" an unwrinkled area of the face over the wrinkled area and then blending the cloned area into the surrounding area. The result is surprisingly natural.

Here's what you need to do:

1. Click the **Standard Edit** button to enter the Standard Edit mode.

2. From the Toolbox, select the **Zoom** tool, as shown in Figure 14.1.

3. Click once or twice on the area you want to fix, to zoom in on the wrinkles, as shown in Figure 14.2.

4. From the Toolbox, select the **Healing Brush** tool, as shown in Figure 14.3. Right-click (Mac: click and hold) the **Spot Healing Brush** button, and then select **Healing Brush Tool** from the menu.

5. In the **Options** bar, shown in Figure 14.4, select a relatively small brush. Then pull down the **Mode** menu, select **Normal**, and make sure the **Sampled** option is selected.

Figure 14.4

Configure the Healing Brush tool.

6. Now you need to select the area of the face you want to clone. Find an unwrinkled area of the face that is near the wrinkle, like that shown in Figure 14.5. Hold down **Alt** (Mac: **Option**) and click once in this area.

7. After you've selected the area to clone, you can now start "painting" the cloned area over the wrinkled area. To do this, click and drag the cursor over the wrinkles, as shown in Figure 14.6. As you drag over the area, the area you selected in step 6 is "cloned" under the cursor, effectively painting smooth skin over the wrinkled skin. Note, however, that the full effect isn't visible until you release the mouse button; this is when Elements completes the "healing" process by blending the cloned area into the surrounding area.

Figure 14.5

Select an area to clone.

If you're fixing a very large wrinkle, you might need to repeat steps 6 and 7 several times to resample the cloned area. The same goes if you're fixing multiple wrinkles; you'll need to clone a different area for each wrinkle you want to remove to achieve a natural-looking result.

Figure 14.6

Cloning the good area over the wrinkled area.

Wrinkles healed away with the Healing Brush tool.

The Healing Brush tool is a fast and easy way to make major changes to any portrait. You can even use it to remove freckles, moles, and other facial blemishes—as you'll learn in Chapter 15, "Removing Blemishes."

Figure 14.7

Create a copy of the Background layer.

Figure 14.8

Select the Background copy layer.

Figure 14.9

Use the Healing Brush technique to remove the wrinkles from the Background copy layer.

Figure 14.10

Use the Opacity control to blend the unwrinkled Background copy layer with the original wrinkled layer.

Create a More Subtle Softening with Layers

When you use the Healing Brush tool, you end up removing wrinkles completely. This is okay in many instances, but you could end up giving a 50-year-old the face of a 20-year-old—a rather dramatic change.

A more subtle approach is to remove *some* of the wrinkles, but not all of them. After all, a completely unlined face on an older person looks unnatural. We expect people to show some sign of aging. Leave a trace of wrinkle on the face, and the results are more believable—while still making the subject from the initial photo look more youthful.

The key to reducing wrinkles, rather than eliminating them, is to employ Elements's Layers feature. You combine the original picture (with wrinkles intact) with a duplicate layer that has the wrinkles completely removed; then you blend the two layers so that a small degree of wrinkleness comes through.

All you have to do is follow these steps:

1. Click the **Standard Edit** button to enter the Standard Edit mode.

2. Copy the picture's Background layer by selecting **Layer > Duplicate Layer**. When the Duplicate Layer dialog box appears, as shown in Figure 14.7, accept the default name (Background copy) and click **OK**.

3. Select the **Layers** tab in the Palette Bin, as shown in Figure 14.8. Click the new layer, which should be labeled **Background copy**, to select it.

4. Perform all the steps in the previous Healing Brush procedure to remove the wrinkles from the Background copy layer, as shown in Figure 14.9.

5. Return to the Layers palette and adjust the **Opacity** level, shown in Figure 14.10, until just enough wrinkles return for your taste.

The goal here is to make your subject look natural. That means adding back enough wrinkles to be believable, but not so many that they become dominant again. You'd be surprised how just a hint of age lines can look significantly better than a completely smooth face.

A more realistic portrait, with just a hint of wrinkles blended in.

How to Avoid Shooting Wrinkles

When you're taking candid photos, there's not much you can do about a subject's wrinkles. It's a different situation when you're in the photo studio, of course, as professional glamour photographers will testify.

First, know that makeup does wonders. A skillful application of the proper base and pancake will fill in the wrinkles and smooth out the face.

Then you can go to work with a whole battery of photographic tricks. Soft, diffused lighting works to minimize wrinkles, so put a lamp-shade over any bare light bulbs and, if you're using professional lighting, bounce the light or put a diffuser screen over the floods. In this instance, natural lighting is better than incandescent or florescent lighting; definitely avoid harsh, direct lighting.

For a more extreme glamour effect, consider using a soft-focus filter or even smearing a thin layer of Vaseline on the camera lens. Soften the photo and you soften the wrinkles—it's as simple as that.

NOTE

Learn more about how layers work in Chapter 1, "Making Quick Fixes with Photoshop Elements."

REMOVING BLEMISHES

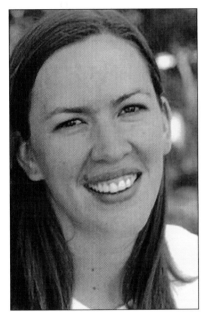

Before

After

"Your subjects will be impressed when you use Photoshop Elements to remove their blemishes"

People like to look their best in pictures. Which means that even a perfect picture might still require some touching up to remove any physical imperfections captured by the camera lens.

Some people are particularly sensitive about skin blemishes, from freckles and acne to moles and scars. Your subjects will be impressed when you use Photoshop Elements to remove these types of blemishes—and make them look even more gorgeous than they are in person.

Remove Small Blemishes with the Spot Healing Brush Tool

Here's a good example. The woman in this photo has several skin blemishes, including some freckles on her neck and a prominent mole on her upper lip. We can use Elements to remove all these blemishes, with a minimum of fuss and bother.

Figure 15.1

Select the Zoom tool.

Figure 15.2

Zoom in on the blemish you want to fix.

Figure 15.3

Select the Spot Healing Brush tool.

Click just that once—don't try to paint over the blemish!

A lovely lady with a mole on her upper lip and freckles on her neck.

The easiest way to remove small moles and blemishes is with Elements's new Spot Healing Brush tool. This is a simple operation that replaces the blemish with a new patch of skin, automatically calculated from the surrounding skin area.

This technique is particularly suited to the types of small freckles our subject has on her neck. Here's what you need to do:

1. Click the **Standard Edit** button to enter the Standard Edit mode.
2. From the Toolbox, select the **Zoom** tool, as shown in Figure 15.1.
3. Click once or twice to zoom in on the blemish you want to fix, as shown in Figure 15.2.

4. From the Toolbox, select the **Spot Healing Brush** tool, shown in Figure 15.3.

5. In the **Options** bar (shown in Figure 15.4), pull down the **Brushes** menu and select a soft-edged brush. Next, select a **Size** just slightly larger than the blemish and make sure the **Type** is set to **Proximity Match**.

6. Position your cursor over the blemish, as shown in Figure 15.5; then click once.

This technique does a good job 90% of the time—and a horrible job 10% of the time. Sometimes Elements "heals" the area with a much darker or different-textured spot. If this happens, press **Ctrl+Z** (Mac: ⌘-**Z**) to undo the operation, and then use the next technique instead.

Figure 15.4

Set the options for the Spot Healing Brush tool.

Figure 15.5

Click once to heal the blemish.

No more freckles!

Replace Bigger Blemishes with the Healing Brush Tool

> Try This Instead

The Spot Healing Brush tool works on smaller blemishes—on "spots," as the name implies. If you're faced with a larger blemish, such as a large mole or a field of freckles, you need to use the full-blown Healing Brush tool.

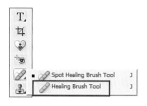

Figure 15.6

Select the Healing Brush tool.

We'll use the Healing Brush tool to fix the large mole over our subject's upper lip. Here's how it works:

1. Click the **Standard Edit** button to enter the Standard Edit mode.

2. From the Toolbox, select the **Zoom** tool and zoom in on the area you want to fix.

3. From the Toolbox, select the **Healing Brush** tool, as shown in Figure 15.6. Right-click (Mac: click and hold) the **Spot Healing Brush** button, and then select **Healing Brush Tool** from the menu.)

Figure 15.7

Configure the Healing Brush tool.

4. In the **Options** bar, shown in Figure 15.7, select a relatively small brush. Then pull down the **Mode** menu, select **Normal**, and make sure the **Sampled** option is selected.

5. Now you need to find an area of the face that matches the skin color and texture directly around the blemish. After you've located the area to clone, position the cursor over that area, as shown in Figure 15.8. Then hold down **Alt** (Mac: **Option**) and click the mouse button to sample that area.

Figure 15.8

Select an area to clone.

6. After you've sampled that clear area of skin, you can now start "painting" the cloned area over the blemish area. To do this, click and drag the cursor over the blemish area, as shown in Figure 15.9. As you drag over the area, the area you selected in step 5 is "cloned" under the cursor, effectively painting clear skin over the blemish. Note, however, that the full effect isn't visible until you release the mouse button; this is when Elements completes the "healing" process by blending the cloned area into the surrounding area.

Figure 15.9

Clone the selected area over the blemish.

This technique can be used to remove all sorts of blemishes—scars, pimples, freckles, you name it. It's also great for removing wrinkles, as you learned in Chapter 14, "Softening Wrinkles."

A blemish-free portrait.

How to Avoid Photos with Blemishes

It's difficult to shoot a perfect picture of an imperfect subject. However, makeup can do wonders, especially when it comes to covering up freckles and other minor blemishes.

If you're curious about how the pros approach this problem, investigate the use of a soft-focus filter; many consumer-level digital cameras let you use add-on lens filters like this. A soft-focus filter won't remove the blemishes, but it will soften them to some degree.

WHITENING YELLOW TEETH

Before

After

"Fortunately, you can brighten your subject's day by brightening his smile— with Photoshop Elements"

Not all of us are blessed with a George Hamilton–quality smile. Caffeine, nicotine, soft drinks, and age take a toll on our sparkling whites, and yellowed and darkened teeth get reproduced faithfully by a digital camera. Fortunately, you can brighten your subject's day by brightening his smile—with Photoshop Elements.

Brighten the Smile with the Dodge Tool

If your subject has a mouthful of less-than-white teeth, like the gentleman here, you can use Elements to brighten up that smile, after the fact. The easiest way to do this is to use Elements's Dodge tool and "paint" each tooth brighter. Here's how to do it:

Not everyone has perfectly white teeth.

Figure 16.1

Select the Zoom tool.

Figure 16.2

Select the Dodge tool.

1. Click the **Standard Edit** button to enter the Standard Edit mode.
2. From the Toolbox, select the **Zoom** tool (shown in Figure 16.1) and click several times on the subject's face to zoom in on the mouth area.
3. From the Toolbox, select the **Dodge** tool, as shown in Figure 16.2. Right-click (Mac: click and hold) the **Sponge** tool button, and then select **Dodge Tool** from the menu.
4. In the **Options** bar, shown in Figure 16.3, select a smallish-sized soft-edged brush; then set the **Range** to **Midtones** and the **Exposure** to **50%**.
5. Position your cursor over the first tooth and, very carefully, start painting the tooth, as shown in Figure 16.4, until you achieve the desired brightness level. You might need to paint several times

over an area to reach the desired brightness. Be careful not to paint over the edges of each tooth; restrict your painting to the inside area of each tooth.

6. When you're finished painting one tooth, move to another tooth and paint over that one. Repeat for each visible tooth in the mouth.

This is a quick and dirty solution that's more effective than you might think at first. It's especially good when the subject is at some distance from the camera, so you don't see the teeth's texture up close. And remember—the more you dodge, the brighter the teeth get!

Figure 16.3

Set the options for the Dodge tool.

Figure 16.4

Use the Dodge tool to paint each tooth brighter.

A brighter smile after using the Dodge tool.

CAUTION

Brighten the teeth too much and you'll lose the teeth's texture, thus making the smile look unnatural.

Change the Color of the Teeth with the Hue/Saturation Control

If you think the Dodge tool method results in an unnatural brightening, or if the subject's teeth are particularly yellowed, it's time for more complex dental work. This method involves masking off the tooth area and adjusting the color hue and saturation of the teeth.

Try This Instead

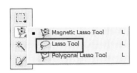

Figure 16.5

Select the Lasso tool.

Figure 16.6

Set the Feather control to 1 pixel.

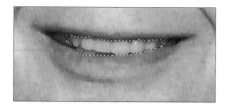

Figure 16.7

Draw a selection around the teeth with the Lasso tool.

Figure 16.8

Reduce the yellow cast of the teeth.

Figure 16.9

Lighten all the colors of the teeth.

Here's what you need to do:

1. Click the **Standard Edit** button to enter the Standard Edit mode.

2. Use the **Zoom** tool to zoom in on the subject's mouth.

3. From the Toolbox, select the **Lasso** tool, shown in Figure 16.5. Right-click (Mac: click and hold) the **Magnetic Lasso** button and then select **Lasso Tool** from the menu.

4. In the **Options** bar, as shown in Figure 16.6, set the **Feather** control to **1** pixel.

5. Use the **Lasso** tool to draw a selection around the teeth, as shown in Figure 16.7. Make sure not to include any lips or gums.

6. Select **Enhance** > **Adjust Color** > **Adjust Hue/Saturation** to open the Hue/Saturation dialog box.

7. The first thing to change is the yellow cast. Pull down the **Edit** menu and select **Yellows**, as shown in Figure 16.8. Then drag the **Saturation** slider to the left until the yellow cast disappears.

8. Now you need to brighten the teeth, overall. Still in the Hue/Saturation dialog box, pull down the **Edit** menu and select **Master**, as shown in Figure 16.9. Then drag the **Lightness** slider to the right until you reach the desired brightness.

9. When you're satisfied with the results, click **OK** to close the dialog box.

The result is a much more natural-looking smile than with the Dodge tool method. That's because this method retains the texture of the teeth, as well as the relative brightness from tooth to tooth.

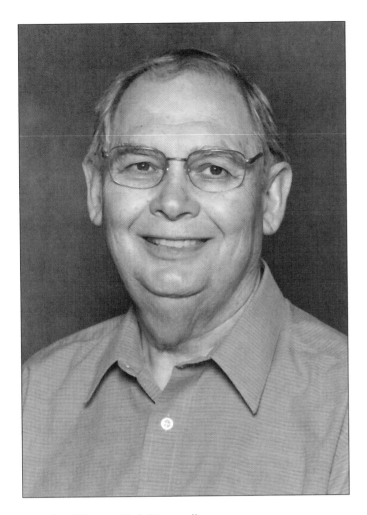

A more natural, whiter, and brighter smile.

How to Shoot Whiter Teeth

As a photographer, there's not much you can do if your subjects have dark or yellow teeth, except tell them to keep their mouths closed! On the other hand, your subjects can reduce the problem beforehand by going to the dentist and taking advantage of the latest teeth-brightening procedures—or by using one of those over-the-counter teeth-brightening products. They really work!

GETTING RID OF BRACES

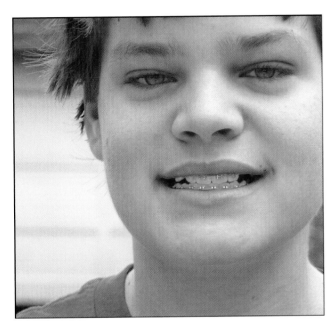

Before

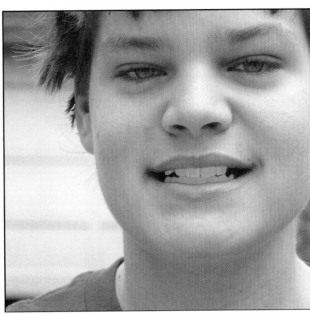

After

"This isn't photographic wizardry; it's another instance of using Photoshop Elements to remove unwanted elements from the picture"

If your kids have crooked teeth, sooner or later you'll make that very expensive trip to the orthodontist. And, of course, your kids will hate you for trying to improve their dental appearance and refuse to smile until the braces come off. No young person—especially in their teen years—wants to leave a photographic record of their metal mouthwork.

For that rare occasion when you can actually get your braces-wearing offspring to smile for the camera, you can appease their sense of vanity by promising them a pristine smile, sans braces. This isn't photographic wizardry; it's another instance of using Photoshop Elements to remove unwanted elements from the picture.

Paint Over the Braces with the Brush Tool

No matter how you approach the problem, digitally removing braces is a time-consuming procedure. Giving the young fellow in this photo a smile without those embarrassing orthodontic appliances requires zooming in on that smile and painstakingly painting over each and every piece of metal. You'll need a sure hand and a lot of patience, but your child should thank you. (They should, but they probably won't—kids today!)

NOTE

In most photos, teeth are not perfectly white. Most teeth are off-white to begin with and often appear slightly gray because of shadows.

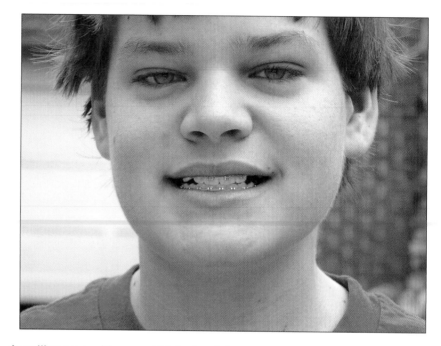

A smiling teen with a mouthful of metal.

Figure 17.1

Select the Zoom tool.

Here's how to approach the problem:

1. Click the **Standard Edit** button to enter the Standard Edit mode.
2. From the Toolbox, select the **Zoom** tool (shown in Figure 17.1).
3. Click once or twice on the subject's mouth to zoom in on the area to retouch.
4. From the Toolbox, select the **Brush** tool, as shown in Figure 17.2.
5. In the Options bar, shown in Figure 17.3, pull down the **Brushes** menu and pick a soft-edged brush; then click the **Size** control and choose a relatively small brush size—something small enough to fit into the corners of each tooth. Make sure the **Mode** is set to **Normal** and the **Opacity** is **100%**.
6. You have to retouch each tooth separately, and it's important that you accurately match the color of each tooth. To this end,

Figure 17.2

Select the Brush tool.

Figure 17.3

Configure the Brush tool options.

click the **Set Foreground Color** control in the Toolbox (shown in Figure 17.4) to display the **Color Picker** dialog box. You're not going to set the color in the dialog box, however. Instead, move your cursor to an area on the tooth either directly above or below the metalwork. The cursor turns into an eyedropper; click the cursor to sample the color of this area and set it as the foreground color. Click the **OK** button to close the dialog box.

7. Now it's time to paint over the braces—for this tooth only. (You have to go one tooth at a time because each tooth is a slightly different color.) Position the cursor over the metalwork, as shown in Figure 17.5; then click and hold the mouse button and paint the new color over this area. Stay within the confines of this tooth, and try not to paint over the tooth's edges.

8. When you're satisfied with the job on this tooth, repeat steps 6 and 7 for each visible tooth. Take care to sample the correct color for each tooth you paint—because of shadowing, different teeth will be different colors.

The result, as you can see here, removes the braces but doesn't look quite natural, especially in close-up photos. (It's a better technique for when the subject is at a distance.) That's because you've removed the texture from each tooth; teeth seldom look this uniform.

If you don't like the results, you'll need to try another technique—which we'll discuss next.

Figure 17.4

Set the foreground color.

Figure 17.5

Paint over the braces, tooth by tooth.

If you've painted with the wrong color, the tooth might appear too white—and too artificial. If this is the case, press **Ctrl+Z** (Mac: ⌘-**Z**) to undo your changes, and repaint after sampling a different area from the problem tooth.

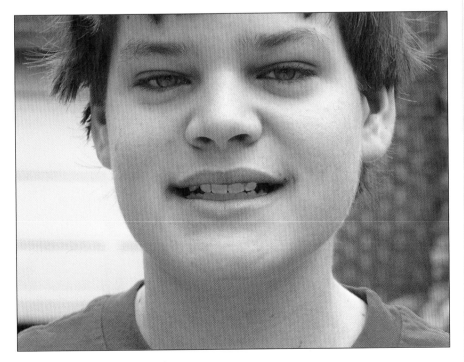

A brighter smile with the braces painted over.

 Try This Instead

Clone Stamp Tool

Figure 17.6

Select the Clone Stamp tool.

Painting white teeth over can result in an unnatural appearance; teeth typically aren't a uniform color and texture. A better approach, especially for portrait photography, is to use Elements's Clone Stamp tool to clone the color and texture from one area of the tooth over the area obscured by braces. It's a little tedious, but it can create a much more satisfactory result. The Clone Stamp tool works just like the Healing Brush tool, except it doesn't try to blend the edges of the cloned area into the surrounding area. The Clone Stamp tool is a better tool when you're dealing with hard edges, as with the task at hand.

Here's what you need to do:

Figure 17.7

Configure the Clone Stamp tool options.

1. Click the **Standard Edit** button to enter the Standard Edit mode.

2. From the Toolbox, select the **Zoom** tool and zoom in on the area to retouch.

3. From the Toolbox, select the **Clone Stamp** tool, as shown in Figure 17.6.

4. In the Options bar, shown in Figure 17.7, pull down the **Brushes** menu and pick a soft-edged brush. Then click the **Size** control and choose a relatively small brush size—something small enough to fit into the corners of each tooth. Make sure the **Mode** is set to **Normal** and the **Opacity** is set to **100%**.

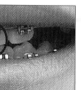

Figure 17.8

Select a clean area of the tooth to clone.

5. As with the previous method, you'll need to clone each tooth one at a time. Select an area to clone by positioning the cursor over a clean area of the tooth, either directly above or below the metal braces (as shown in Figure 17.8). Then hold down the **Alt** (Mac: **Option**) key and click the mouse to sample that area.

6. Now it's time to copy the cloned area over the braces. Position your cursor over the metalwork, and then click and drag your mouse over the area to make the braces disappear, as shown in Figure 17.9.

7. Repeat steps 5 and 6 for each visible tooth.

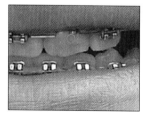

Figure 17.9

Copy the cloned area over the metal braces.

Because the area you copy over is probably larger than the area you cloned, you might need to paint a small swatch and then resample a new area to clone—effectively repeating steps 4 and 5 several times on each tooth. Otherwise, you might end up cloning the top of the braces over the bottom of the braces! The result of all this effort is a more natural-looking smile—and a picture your child won't be embarrassed to show his friends!

A braces-less smile, thanks to dental cloning.

How Not to Take a Picture with Braces

This is a tough problem to avoid; if a kid has braces, he has braces! Of course, there are many new options for braces wearers these days, including so-called "invisible" braces, made from a clear ceramic or plastic material. Then there's the approach I used to take back when I wore braces as a kid—just keep your mouth closed!

TAMING UNRULY HAIR

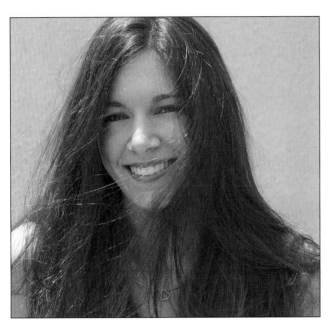

Before

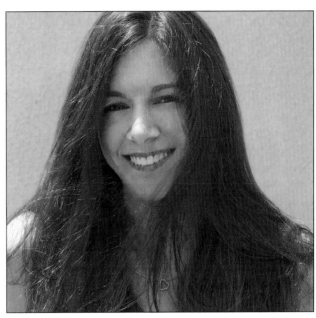

After

S ometimes you just have a bad hair day. Maybe it's windy, maybe you forgot your comb, maybe your hair spray isn't working. Whatever the case, your hair doesn't always stay in place, and a few stray strands can ruin an otherwise-perfect picture.

Until you put that messy hair back in place with Photoshop Elements, that is.

"Whatever the case, your hair doesn't always stay in place, and a few stray strands can ruin an otherwise-perfect picture"

Replace Messy Hair with the Clone Stamp Tool

The way you get rid of stray strands of hair is to clone them away with Elements's Clone Stamp tool. You can't just delete the hair because you'd be left with cutouts in your picture where the hair used to be. No, what you have to do is clone a clean part of the face or background over the hair. If you do it right, you'll never know the hair was out of place to begin with.

Take this picture of a lovely long-haired lady outdoors on a breezy summer day. I like long-haired ladies, and I like breezy summer days, but the combination often results in wild, messy hair, such as what you see here. The solution is to digitally retouch the photo so we can see more of that beautiful face—and create more of a clean-cropped hairdo.

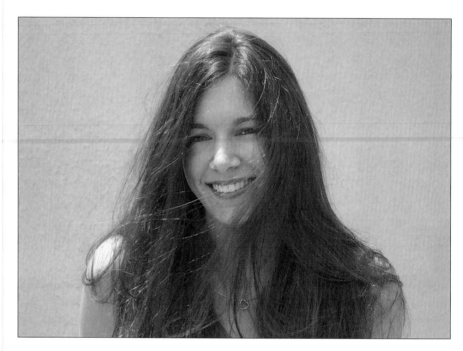

A lovely young lass with her long hair blowing every which way.

Here's how you do it:

1. Click the **Standard Edit** button to enter the Standard Edit mode.
2. From the Toolbox, select the **Zoom** tool, shown in Figure 18.1, and zoom in on the area of the face you want to retouch.
3. From the Toolbox, select the **Clone Stamp** tool, as shown in Figure 18.2.

Figure 18.1

Select the Zoom tool.

Figure 18.2

Select the Clone Stamp tool.

Figure 18.3

Set the options for the Clone Stamp tool.

4. In the Options bar, shown in Figure 18.3, select a small soft-edged brush; then make sure the **Mode** is set to **Normal** and the **Opacity** is set to **100%**.

5. Position the cursor over a clean area just beside a strand of hair, as shown in Figure 18.4. Then press **Alt** (Mac: **Option**) and click the mouse to sample this spot.

6. Move the cursor over the edge of the hair you want to remove, and then click your mouse and paint a small portion of the cloned area over the hair, as shown in Figure 18.5. Don't paint too large an area, however; the key to this technique is taking a large number of samples and painting very small areas at a time.

7. Repeat steps 5 and 6 until you've successfully cloned over all the hair you want to remove.

After you've removed all the hair blowing across your subject's face, you can also remove wild hair around the subject's head. This involves using the Clone Stamp to clone pieces of the background over the blowing strands of hair, as shown in Figure 18.6, effectively giving the subject's hair a little trim. This can be relatively easy if you have a simple background, like the one in our example, or a real pain if you have an extremely complex background.

It sounds easy, but it's really time-consuming if you want to do it right. The temptation is to paint away large swatches of hair at a time, but that doesn't achieve the best results. To end up with the most natural facial texture, you have to clone away small patches of hair, constantly resampling the area to clone. Sample, paint, sample, paint, sample, paint—lots and lots of small steps to get rid of all the strands of hair!

Figure 18.4

Select a clean area to sample.

Figure 18.5

Paint the cloned area over the hair.

Figure 18.6

Trimming around the subject's head.

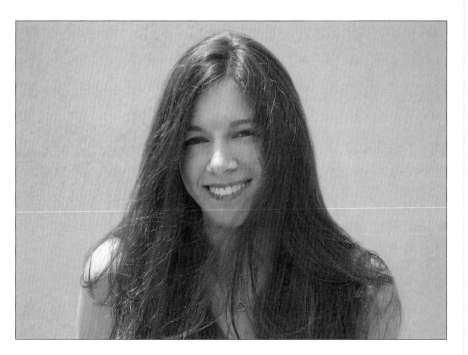

The lovely lady with a little less wild hair.

Change the Hair Color

While we're on the topic of hair, here's a quick technique for changing the hair color in a picture. All you have to do is use the Color Replacement tool, and you can turn a blonde into a brunette, or even a red head.

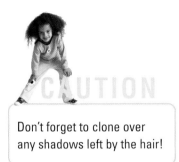

Don't forget to clone over any shadows left by the hair!

Don't like your hair color? Then change it!

Here's all you have to do:

1. Click the **Standard Edit** button to enter the Standard Edit mode.

2. From the Toolbox, select the **Color Replacement** tool, shown in Figure 18.7. (Right-click the **Brush** tool button; then select the **Color Replacement** tool from the menu.)

3. In the Options bar, shown in Figure 18.8, select a rather large brush, and make sure the **Mode** is set to **Color**. Also set the **Tolerance** to **30%**.

4. In the Toolbar, click the **Set Foreground Color** swatch to display the **Color Picker** dialog box, shown in Figure 18.9. Select the color you want the hair to be; then click **OK**.

Figure 18.7

Select the Color Replacement tool.

Figure 18.8

Set the options for the Color Replacement tool.

5. Use the **Color Replacement** tool to paint over the subject's hair, as shown in Figure 18.10. The highlights of the hair should change color as you paint over them.

6. If the subject's hair contains several shades of color, you might need to repeat step 5, clicking different areas of the hair.

The result is instant hair coloring—no dying necessary.

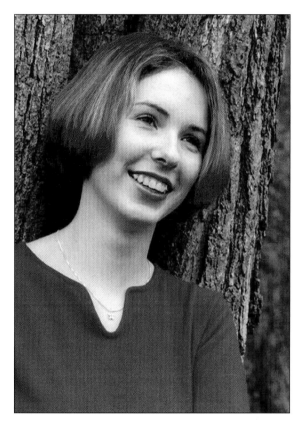

Instant hair coloring.

Figure 18.10

Paint over the hair to change its color.

How to Shoot Better Hair

If you're shooting with a point-and-click digital camera with no extra lighting, the hair you shoot will be the hair you get. Just make sure the subject uses a comb or brush beforehand, and maybe even a little hairspray, especially if you're shooting outdoors.

If you're shooting a more formal portrait, here's a tip for highlighting the hair. In addition to the front flood lights, put a key spot behind the subject, aimed up at the back of her head. This should create a subtle backlighting effect, which will outline the subject's head and give her hair a slight shine.

For the full effect, don't forget to paint over the subject's eyebrows!

SMOOTHING SKIN TONE AND COLOR

Before

After

When you take a close-up shot of a person, the camera captures all sorts of skin imperfections. You learned how to get rid of large blemishes, scars, and the like in Chapter 15, "Removing Blemishes." But that still leaves a variety of more subtle skin problems to deal with—including off-color flesh tones, blotchy skin, and so on.

"When you take a close-up shot of a person, the camera captures all sorts of skin imperfections"

Adjust the Skin Color

We'll start with the common problem of incorrect flesh tones. This is often a result of bad lighting of one sort or another—either too much, too little, or light with too much of a color cast. Your subject's skin could also be too pale or too dark for your taste; whatever the cause, it's an effect you can fix with Photoshop Elements.

Here's a good example of skin color that's just not quite right. The blushing bride in this photograph looks like she's spent too much time out in the sun; her flesh tone is both too red and too saturated. We want to tone the color down a little and remove some of the red cast.

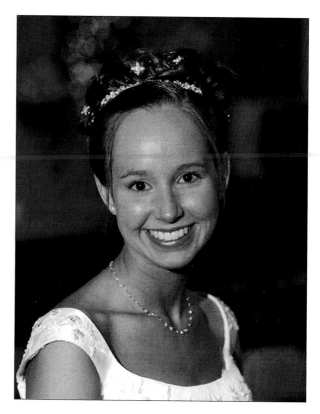

A bride with too-red skin.

Figure 19.1

Select the Magnetic Lasso tool.

You can easily fix these flesh tone problems with Elements's Hue/Saturation control. Here's what you need to do:

1. Click the **Standard Edit** button to enter the Standard Edit mode.

2. The first thing we'll do is select the exposed flesh to edit. Go to the Toolbox and select the **Magnetic Lasso** tool, as shown in Figure 19.1.

Figure 19.2

Set the Feather to 3 pixels.

3. To avoid putting too hard an edge around the selected skin area, go to the Options bar (shown in Figure 19.2) and enter **3 px** (pixels) into the **Feather** box.

4. Use the **Magnetic Lasso** tool to carefully draw around the skin area you want to edit, as shown in Figure 19.3.

5. Select **Enhance > Adjust Color > Adjust Hue/Saturation** to open the Hue/Saturation dialog box.

6. Skin tone is composed primarily of the color red, so this is the color we want to work with. Pull down the **Edit** menu and select **Reds**, as shown in Figure 19.4; then adjust the **Saturation** slider to the left to reduce the red level. (If you need to add more red to the skin color, drag the slider to the right instead.)

7. When you're satisfied with your results, click **OK**.

The result? Much healthier-looking skin and a nice—but not quite perfect, yet—bridal photo.

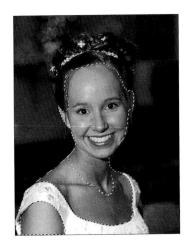

Figure 19.3

Draw around the skin area you want to correct.

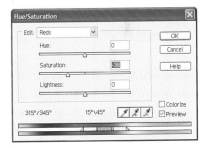

Figure 19.4

Adjust the saturation of the red color.

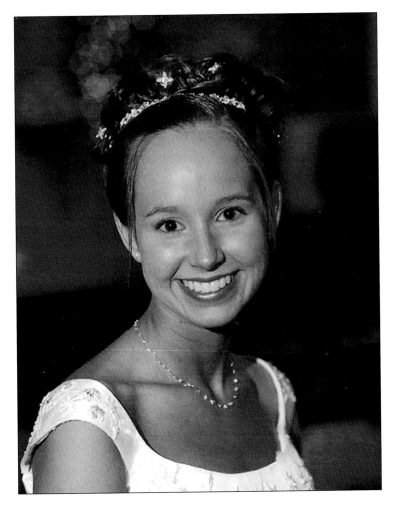

A much healthier-looking bride.

Smooth the Skin—and Make It Glow

Figure 19.5

Create a duplicate of the background layer.

Figure 19.6

Open the Layers palette and select the Background Copy layer.

Figure 19.7

Apply the Gaussian Blur filter to the copied layer.

Figure 19.8

The result of blurring the copied layer.

Even when the flesh tones are correct, some close-up photos are less than flattering to their subjects. The closer you get with the camera, the more the lens captures every little skin imperfection. Not that you want to create a professional glamour photograph, but it would be great if you could smooth out uneven skin, soften freckled patches, and add a kind of glamour glow to the subject. Doing this requires slightly blurring parts of the picture to create a kind of soft-focus effect—without losing the overall picture sharpness.

Here's how you go about glamorizing your subject:

1. Click the **Standard Edit** button to enter the Standard Edit mode.

2. Make a copy of the current layer by selecting **Layer** > **Duplicate Layer**; when the Duplicate Layer dialog box appears (see Figure 19.5), accept the name **Background Copy** and click **OK**.

3. In the Palette Bin, select the **Layers** tab (shown in Figure 19.6) and then select the **Background Copy** layer.

4. Now you need to blur this layer. Select **Filter** > **Blur** > **Gaussian Blur**. When the Gaussian Blur dialog box appears (shown in Figure 19.7), adjust the **Radius** control until the picture is sufficiently blurry (probably somewhere between 3 and 6 pixels). Click **OK** when you're done.

5. Your picture now looks extremely blurry, as shown in Figure 19.8. You need to blend this blurry layer with the still-sharp original layer, so go back to the Layers palette and adjust the **Opacity** control to **50%**, as shown in Figure 19.9.

6. Your picture now looks only slightly blurred, as you can see in Figure 19.10. The problem is that you don't want the entire picture to be blurred, only the skin area. So now you must add some sharpness back in the non-skin areas, which you do by erasing some of the duplicate layer. Start by going to the Toolbox and selecting the **Eraser** tool, as shown in Figure 19.11.

7. Go to the Options bar, shown in Figure 19.12, pull down the **Brushes** menu, and select a soft-edged brush. Also select a relatively small **Size** and make sure **Opacity** is set to **100%**.

8. Click and drag the mouse over those areas of the face you want to sharpen—eyebrows, eyes, teeth, lips, hair, and so on, as shown in Figure 19.13. What you're doing is erasing parts of the blurred layer so the sharp original layer shows through. Avoid dragging the Eraser tool over open areas of skin.

9. When you're done touching up around the face, you might also want to sharpen other areas of the picture. Return to the Options bar and select a larger brush size; then click and drag the **Eraser** tool around the other non-skin areas of the picture.

10. To finalize the effect, select **Layer** > **Flatten Image**. (You need to do this before you perform any additional retouching.)

The result is a very professional-looking portrait, with the kind of soft-focus effect you'd pay a professional glamour photographer big bucks for!

Figure 19.9

Change the blurred layer's Opacity to 50%.

Figure 19.10

The blurred layer blended with the original layer.

Figure 19.11

Select the Eraser tool.

Figure 19.12

Setting the options for the Eraser tool.

Figure 19.13

Sharpening parts of the picture with the Eraser tool.

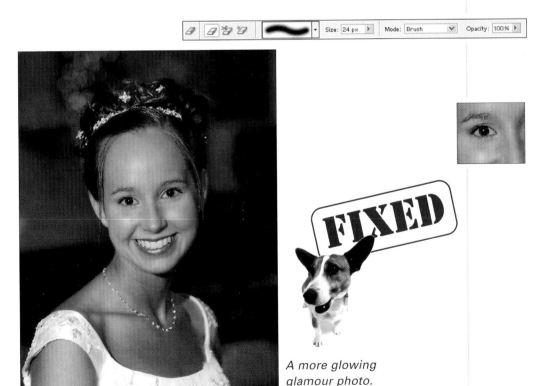

A more glowing glamour photo.

TIP

You get a nice glamour portrait effect by leaving the background of the picture blurry, which means skipping step 9.

How to Shoot Better-looking Skin

The quality of the flesh you capture with your digital camera is dependent on several factors—the subject's skin (of course!), the amount and type of makeup applied, the lighting, and the lens you use. Because you don't have any control over the subject's skin, the best you can do is offer makeup advice and then go to work on the lighting. Harsh light accentuates skin problems, so avoid your camera's built-in flash and use either soft natural lighting or photo floods with diffusers. If your camera accepts lens filters, try using a soft-focus filter; if not, experiment with putting a thin layer of gauze over the lens or even smearing a bit of Vaseline over the lens surface.

And don't forget to use distance to your advantage. The farther away the subject is from the lens, the less noticeable any skin imperfections will be. If the subject has *really* bad skin, shoot him from a distance—with the lights turned down!

MAKING A PLAIN FACE MORE GLAMOROUS

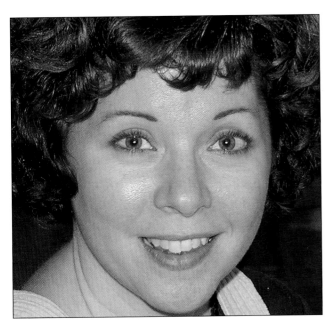

Before

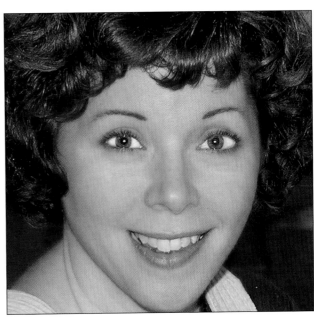

After

Throughout the previous chapters in this section, you learned how to fix a variety of facial flaws, from bad skin to yellow teeth. Now let's take the next step and learn how to make a normal close-up photo look like a glamour portrait—even if the subject isn't wearing make up!

"Now let's take the next step and learn how to make a normal close-up photo look like a glamour portrait…"

Fix the Obvious Flaws

To show you how a little Photoshop Elements magic can make a big difference, we're going to use a candid snapshot of my sister Melanie, nothing posed or glamorous about it. By the time we're finished, you'll think we spent hours working with lights and makeup—which we most definitely didn't!

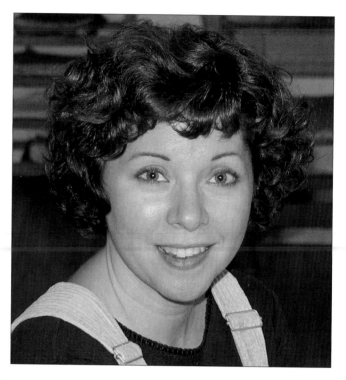

A candid close-up, with no fancy lights or makeup.

But before we start with the glamour touch-up, let's fix any obvious flaws that are apparent in the picture, using the techniques you've learned earlier in this book. In particular, be sure to:

- Remove any red eye (Chapter 12)
- Get rid of dark circles under the eyes (Chapter 13)
- Soften wrinkles and crows feet (Chapter 14)
- Remove any moles, scars, or other blemishes (Chapter 15)
- Whiten dark or yellowed teeth (Chapter 16)
- Remove unwanted braces (Chapter 17)
- Trim or clone over unruly strands of hair (Chapter 18)

In addition, you should make any necessary brightness, contrast, and color corrections and crop the picture to draw attention to the subject's face.

Smooth the Skin Tone

After the basic retouching is out of the way, you should perform the skin smoothing technique you learned in Chapter 19, "Smoothing Skin Tone and Color." As you recall, this involves making a copy of the background layer, applying the Gaussian Blur filter to this layer, backing off the layer's opacity to 50%, and then erasing areas of the blurred layer that you want to remain sharp. As you can see, this simple technique makes a big difference and is a good first step toward producing a glamour portrait.

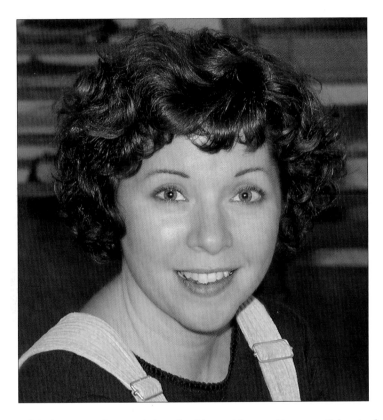

Our candid close-up after applying the blurred-layer skin smoothing technique.

After you've completed this skin smoothing, you need to combine the two layers into one. You do this by selecting **Layer** > **Flatten Image**.

Dull the Shiny Skin

Some people have naturally shiny skin. Although makeup can help dull the shiny areas, bright lights work to make the shine shinier. When you're shooting with any sort of direct lighting, especially your camera's flash, you'll end up with some shiny skin in your close-up shots.

Figure 20.1

Select the Healing Brush tool.

Figure 20.2

Change the Mode to Darken in the Options bar.

Figure 20.3

Select a nonshiny spot.

Figure 20.4

Clone the darker flesh over the shiny area.

You remove shiny areas by cloning over them with Elements's Healing Brush tool. But you don't want to simply clone new patches of skin; you only want to clone the brightness level of a normal (non-shiny) area. You do this by changing the mode of the Healing Brush to Darken, like this:

1. Click the **Standard Edit** button to enter the Standard Edit mode.

2. From the Toolbox, select the **Healing Brush** tool, as shown in Figure 20.1. Right-click (Mac: click and hold) the **Spot Healing Brush** button, and then select **Healing Brush Tool** from the menu.

3. In the Options bar, shown in Figure 20.2, select a fairly small brush size, change the **Mode** to **Darken**, and make sure the **Sampled** option is selected.

4. Position your cursor over a nonshiny area of skin, as shown in Figure 20.3, and then press **Alt** (Mac: **Option**) and click the mouse to sample that spot.

5. Move your cursor over the shiny area, and then hold down the mouse button and paint this area with the darker sample, as shown in Figure 20.4. Remember that the final effect doesn't appear until you release the mouse button.

This approach takes a bit of trial and error; if you get a spot too dark, you can undo your changes by pressing **Ctrl+Z** (Mac: ⌘-**Z**). The results, though, look pretty good.

Our close-up photo minus the shiny skin.

Enhance the Lip Color

Do This Next

Next up is the subject's lips. Unless she applied a lot of lipstick beforehand, her lips probably look a little pale. You can correct this by saturating the existing color with Elements's Sponge tool.

Still in the Standard Edit mode, here's what you need to do:

1. Use the **Zoom** tool to zoom in on the subject's lips.
2. From the Toolbox, select the **Sponge** tool, as shown in Figure 20.5.
3. In the Options bar, shown in Figure 20.6, select an appropriate-sized soft-edged brush from the **Brushes** menu, change the **Mode** to **Saturate**, and change the **Flow** setting to **50%**.
4. Paint over the lips with the **Sponge** tool, as shown in Figure 20.7, until the lip color is saturated enough for your taste.

Figure 20.5

Select the Sponge tool.

Figure 20.6

Set the options for the Sponge tool.

Figure 20.7

Paint over the lips with the Sponge tool.

Same subject, more colorful lips.

If the resulting lip color is too intense, undo your changes and try it again, this time using a **Flow** setting of **25%**.

Figure 20.8

Select the Dodge tool.

Figure 20.9

Set the options for the Dodge tool.

Figure 20.10

Paint over the white area of the eye.

Whiten the Eyes

Another trick for creating a glamorous photo is to make the eyes appear brighter, which you do by whitening the whites of the eyes with the Dodge tool. Staying in the Standard Edit mode, here's what you need to do:

1. Use the **Zoom** tool to zoom in on the subject's eyes.

2. From the Toolbox, select the **Dodge** tool, as shown in Figure 20.8. Right-click (Mac: click and hold) the **Sponge** tool button, and then select **Dodge Tool** from the menu.

3. In the Options bar, shown in Figure 20.9, select a small soft-edged brush from the **Brushes** menu, change the **Range** to **Midtones**, and change the **Exposure** setting to **50%**.

4. Click and drag the **Dodge** tool over the white area of the eye, as shown in Figure 20.10, until you achieve the whiteness you want.

5. Repeat step 4 for the other eye.

Our subject with whiter whites.

Enhance the Eye Color

Do This Next

While you're brightening the eye, take a minute to add some more color to your subject's irises. You do this by using the Sponge tool to sponge more color *into* the eye, just as you did when you added more color to the lips. Follow these steps while in the Standard Edit mode:

1. Use the **Zoom** tool to zoom in on the subject's eyes.

2. From the Toolbox, select the **Sponge** tool, as shown in Figure 20.11.

Figure 20.11

Select the Sponge tool.

3. In the Options bar, shown in Figure 20.12, select an appropriate-sized soft-edged brush from the **Brushes** menu, change the **Mode** to **Saturate**, and change the **Flow** setting to **50%**.

Figure 20.12

Set the options for the Sponge tool.

4. Very carefully use the **Sponge** tool to paint over the colored area of the eye, as shown in Figure 20.13, until you achieve an appropriate saturation level.

Figure 20.13

Paint over the colored area of the eye.

Our subject, now known as "bright eyes."

 ► # Change the Eye Color

Figure 20.14 *Select the Magnetic Lasso tool.*

Figure 20.15 *Draw around t he iris of the eye.*

Figure 20.16 *Select the Color Replacement tool.*

Sometimes brightening the eye color isn't good enough; what you really want to do is change the subject's eye color completely. You can do this with Elements's Color Replacement tool.

From within the Standard Edit mode, here's what to do:

1. Use the **Zoom** tool to zoom in on the subject's eyes.

2. From the Toolbox, select the **Magnetic Lasso** tool, as shown in Figure 20.14.

3. Use the **Magnetic Lasso** tool to draw around and select the iris of the eye, as shown in Figure 20.15.

4. Select the **Color Replacement** tool from the Toolbox, as shown in Figure 20.16. Right-click (Mac: click and hold) the **Brush** tool button; then select **Color Replacement Tool** from the menu.

Figure 20.17 *Set the options for the Color Replacement tool.*

5. In the Options bar, shown in Figure 20.17, select a small brush and set the **Tolerance** to **30%**.

6. In the Toolbox, click the Set Foreground Color control to display the **Color Picker** dialog box, shown in Figure 20.18. Select the eye color you want and click **OK**.

Figure 20.18 *Select a new eye color.*

7. Position the cursor over the colored area of the iris, making sure not to paint over the black area; then click and drag the brush over the eye until the color is completely changed, as shown in Figure 20.19.

The result of all these changes is somewhat subtle, but it can make a fairly large difference in your photo.

Figure 20.19 *Changing the eye color from green to blue.*

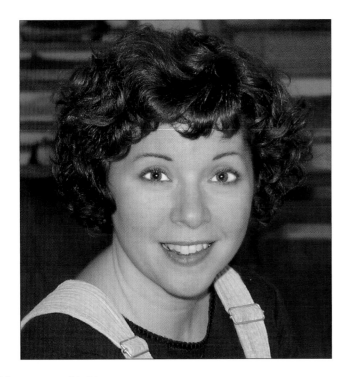

Our subject, now with blue eyes.

Be careful not to pick too bright a color. In real life, most eyes are a more subdued color.

Widen the Smile

Specific Solutions

What do you do if your subject doesn't have a great smile—or isn't smiling at all? Believe it or not, Elements lets you stretch the person's lips into a more pleasing smile, using a special tool called the Liquify filter that lets you move around facial features as if they were Silly Putty. It's a little tricky but pretty cool.

Here's how it works:

1. Select **Filter** > **Distort** > **Liquify** to open the Liquify dialog box, shown in Figure 20.20.

Figure 20.20

Open the Liquify dialog box.

Figure 20.21

Zoom in on the smile.

Figure 20.22

Select the Warp tool.

Figure 20.23

Select a Brush Size.

Figure 20.24

Tug the corner of the lips up into a wider smile.

2. Zoom in on the smile by selecting a larger aspect size from the **Zoom** menu at the bottom-left corner of the dialog box, as shown in Figure 20.21.

3. Click the **Warp** tool button in the upper-left corner of the Liquify dialog box, as shown in Figure 20.22.

4. In the Tool Options bar on the right side of the dialog box, as shown in Figure 20.23, select a **Brush Size** just a little larger than the corners of the person's mouth.

5. Position the brush at one corner of the person's mouth, as shown in Figure 20.24, and then click the mouse and tug the corner up slightly. Don't tug too much, though—or the subject might end up looking like Jack Nicholson's Joker in the *Batman* movie!

6. Repeat step 5 for the other corner of the mouth.

7. Click **OK** to accept your changes.

Pretty neat, eh? You'd think your subject was actually happy!

NOTE

If you don't like the color, press **Ctrl+Z** (Mac: ⌘-**Z**) to undo your changes and then repeat the procedure with a new color.

FIXED

Our subject, now much happier.

Thin Those Chubby Cheeks

You can also use the Liquify filter to sculpt parts of the body. It's a great tool if you want your photo to show your subject a tad thinner than she might appear in real life.

For portraits, the easiest way to make your subject appear thinner is to use the Liquify filter to minimize chubby cheeks. All you have to do is follow these steps:

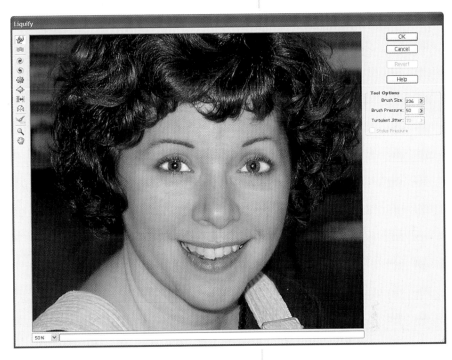

1. Select **Filter** > **Distort** > **Liquify** to open the Liquify dialog box, as shown in Figure 20.25.

2. Click the **Warp** tool button in the upper-left corner of the Liquify dialog box, as shown in Figure 20.26.

3. In the Tool Options bar on the right side of the dialog box, shown in Figure 20.27, select a large **Brush Size**. (I like something in the 350 range.)

4. Position the brush over the edge of the cheek, as shown in Figure 20.28; then click the mouse and tug the cheek inward, slightly.

5. Repeat step 4 for the opposite cheek.

6. Click **OK** to accept your changes.

Like the previous technique, this one is best applied in moderation. Don't tug too much; otherwise, you'll completely change the shape of the person's face and make her unrecognizable. You want to make subtle changes here.

Figure 20.25

Open the Liquify dialog box.

Figure 20.26

Select the Warp tool.

Figure 20.27

Select a large brush size.

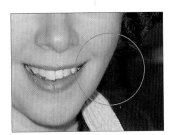

Figure 20.28

Tug the edge of the cheek inward.

TIP

Depending on the photo, you might also need to tug further along the lips to create a natural-looking smile.

FIXED

Our subject with thinner cheeks.

Specific Solutions ▶ **Give a Digital Nose Job**

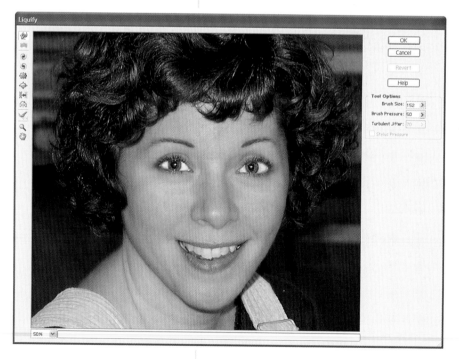

Figure 20.29

Open the Liquify dialog box.

Along the same lines, you can use the Liquify filter to shrink a person's nose. You could use the Warp tool to tug the edges of the nose inward and upward, but there's a more appropriate tool to use—the aptly named Pucker tool, which shrinks an area toward a center spot. Here's how to do it:

1. Select **Filter** > **Distort** > **Liquify** to open the Liquify dialog box, as shown in Figure 20.29.

2. Click the **Pucker** tool button in the upper-left corner of the Liquify dialog box, as shown in Figure 20.30.

3. In the Tool Options bar on the right side of the dialog box, shown in Figure 20.31, select a **Brush Size** about twice as large as the subject's nose; then change the **Brush Pressure** to **20**.

4. Position the cursor over the nose, as shown in Figure 20.32. Then click and hold the mouse button; the nose starts to shrink inward.

5. Continue to hold the mouse button until the nose is the desired size; then release the button.

6. Click **OK** to accept your changes.

This technique is a little harder to pull off than the others, so you might have to experiment for best effect. Click the **Revert** button to undo any change you don't like.

Figure 20.30

Select the Pucker tool.

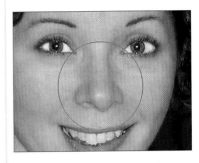

Figure 20.31

Set the Brush Size and Brush Pressure options.

Figure 20.32

Shrink the nose inward to a center point.

Our final fix—a digital proboscis reduction.

How to Shoot a More Glamorous Photo

Glamour photography is an art unto itself. It involves a studied combination of makeup, hair styling, lighting, and lenses. You use the makeup to cover up any skin blemishes or splotchiness and accentuate facial features. The hair styling, of course, is used to create a particular look. Lighting is particularly important because soft, diffused lighting helps to soften the subject's features and give the skin a smoother look. Finally, soft-focus lenses enhance the glamour and further soften the subject's features.

The result can be quite stunning. Even the most average-looking subject can appear extremely glamorous under the care of a talented glamour photographer.

HOW TO FIX *REALLY* BAD PICTURES

CHANGING THE COLOR OF AN OBJECT

Before

After

"Then it's time to use Photoshop Elements to recolor parts of your pictures"

ver have a picture taken in a horrendously colored shirt? Ever wish that a piece of clothing didn't clash with the background? Ever wonder what a particular item would look like in a different color?

Then it's time to use Photoshop Elements to recolor parts of your pictures.

Recolor an Object with the Hue/Saturation Control

You've already learned how to use the Color Replacement tool to recolor hair (Chapter 18, "Taming Unruly Hair") and eyes (Chapter 20, "Making a Plain Face More Glamorous"). It's a pretty good tool when you have a limited area to recolor, but if you want to change the color of a larger object or area of your picture, a different technique is called for.

You might think that all you need to do is paint the object a certain color, using either the Brush or Paint Bucket tool. Try it if you want, but you won't like the results. That's because you'll end up painting over all the texture and detail in the object, as well as any reflections, shadows, and bright spots; all you'll have is an area of flat color, which is not how things appear in real life.

If you've fiddled around with Elements a bit, you might have stumbled across the Replace Color command (Enhance > Adjust Color > Replace Color) and thought that this might be what you use to recolor an object in your photo. A logical assumption—that just happens to be wrong. The Replace Color command does replace a given color with another color, but it doesn't work all that well. It tends to select all items of a similar color in your photo, not just a selected object; it doesn't discriminate enough. It also doesn't do a good job of selecting all the different shades of an object. Bottom line, it's not that useful a tool.

The best approach to recoloring an object, then, is to isolate the object and use the Hue/Saturation control to change the color of the selection. You mask off the entire object you want to recolor by using one of Elements's selection tools to select the object or area. Then you can use the Hue/Saturation control to "colorize" the selection without changing the colors of the rest of your photo.

As an example, we'll work with this photo of my nephew Alec. Alec really likes the color red, as you can see from his shirt. I'm not a big red fan, so I want to recolor his shirt from bright red to a more subdued blue—without changing the color of the red pickup truck in the background.

NOTE

Learn how to select objects and areas in Chapter 2, "How to Fix Only Part of a Picture."

A bright red shirt that would look better in blue.

Figure 21.1

Select the item or area you want to recolor.

Here's how to do it:

1. Click the **Standard Edit** button to enter the Standard Edit mode.

2. Use one of the **Marquee**, **Lasso**, or **Magic Wand** tools to select the object or area you want to recolor, as shown in Figure 21.1. (For selecting most items, I prefer the Magnetic Wand tool.)

3. Depending on what you're selecting, you might want to soften the edges of the selection. To do this, select **Select** > **Feather** to open the Feather Selection dialog box, shown in Figure 21.2. Enter a **Feather Radius** of **2** pixels, and then click **OK**.

4. Now it's time to change the color. Select **Enhance** > **Adjust Color** > **Adjust Hue/Saturation** to open the Hue/Saturation dialog box, shown in Figure 21.3.

5. Check the **Colorize** option. (This is a key step; if you don't check this option, the color change will look extremely artificial.)

6. Adjust the **Hue** slider to the color you want, as shown in Figure 21.4.

Figure 21.2

Feather the edge of your selection.

Figure 21.3

Open the Hue/Saturation dialog box.

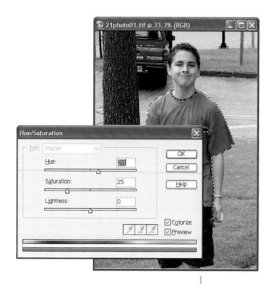

7. If you want a duller or brighter color, adjust the **Saturation** slider to the left (less color) or right (more color).

8. Click **OK** to close the dialog box.

9. Select **Select > Deselect** to deselect the item and view your work.

As you can see, the result is a recolored item that looks as if it was always that color. And nothing else in the picture is affected!

Figure 21.4

Changing the hue and saturation of the selected object.

Our subject with a newly blue shirt.

Try This Instead ## Change Colors with an Adjustment Layer

The only drawback to the previous method is if you happen to select part of an object that shouldn't have its color changed. Because you change the color of the entire selection, if you change a black stripe to a green stripe accidentally, you're kind of stuck.

A more versatile, but slightly more complicated, approach is to use what Elements calls an *adjustment layer* to make your color changes. When you use this method, you can then use the Eraser tool to erase any part of the recolored layer that needs to retain the original color.

For example, here's a picture of my car. It's a nice color, kind of a steel gray, but I've always wondered what it would like in green. I could try recoloring it using the Hue/Saturation control, but it's a bear trying to draw around all the fiddly parts—the lights, the trim, the door handles, what have you. Instead, I'll select the entire car (easy enough to do), recolor it with an adjustment layer, and then erase the new color from all the fiddly parts.

Figure 21.5

Select the item you want to recolor.

Figure 21.6

Feather the edge of the selection.

Figure 21.7

Creating a new adjustment layer.

Figure 21.8

Changing color in the Hue/Saturation dialog box.

My boring gray car.

Here's how to use this approach:

1. Click the **Standard Edit** button to enter the Standard Edit mode.

2. Use one of the **Marquee**, **Lasso**, or **Magic Wand** tools to select the object you want to recolor, as shown in Figure 21.5.

3. If you want to soften the edge of the selection, select **Select** > **Feather** to open the Feather Selection dialog box, shown in Figure 21.6. Enter a **Feather Radius** of **2** pixels; then click **OK**.

4. Now it's time to create an adjustment layer based on the area you selected, which you do by selecting **Layer** > **New Adjustment Layer** > **Hue/Saturation**.

5. This opens the New Layer dialog box, shown in Figure 21.7. Accept the default name for this layer and click **OK**.

6. Elements now opens the Hue/Saturation dialog box, shown in Figure 21.8.

7. Check the **Colorize** option.

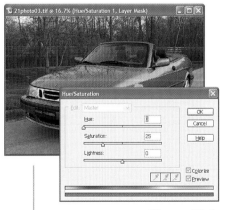

Figure 21.9

Changing the hue and saturation of the selected area.

Figure 21.10

The selected area, recolored.

Figure 21.11

Select the Eraser tool.

Figure 21.12

Configure the Eraser tool in the Options bar.

Figure 21.13

Erase the new color from areas that should remain the original color.

8. Adjust the **Hue** slider to the color you want, as shown in Figure 21.9.

9. If you want a duller or brighter color, adjust the **Saturation** slider to the left (less color) or right (more color).

10. Click **OK** to close the dialog box. The entire area you selected now reflects the color change, as shown in Figure 21.10.

11. Now you need to erase the new color from those areas that shouldn't have been changed. Start by selecting the **Eraser** tool from the Toolbox, as shown in Figure 21.11.

12. In the Options bar, as shown in Figure 21.12, select a relatively small hard-edged brush from the **Brushes** menu and make sure the **Opacity** is set to **100%**.

13. Position the **Eraser** tool over an area you want to uncolor; then click and hold the mouse button to "paint" over the area, as shown in Figure 21.13. As you move the eraser back and forth, the new color is erased and the original color shines through.

The result, as you can see, looks amazingly realistic. And it's a lot easier than trying to mask off all the fiddly parts beforehand!

The formerly gray car, now a bright green.

How to Make Recoloring Easier

The nice thing about being able to digitally change colors after the fact is that you don't have to worry about getting all your colors to match up when you're shooting. This makes it easier to shoot more spontaneous photos and to catch the magic of the moment. Don't worry about the subject's shirt or the color of that object in the background; if the colors clash, use Elements to change them afterward.

That said, colors are easier to change if they're easier to select. If you see a part of your picture that you think you'll want to recolor later, make an effort to isolate it in your picture—especially from objects of similar colors. It's hard to select a dark green object against a slightly less-green background; try to either separate the object physically or position it against a background of a much different color.

Also, color changes look more natural when the colors are rather brightly lit, originally. Changing the color of shadows doesn't always work out that well, or at the very least limits the range of acceptable colors you can use. So, if you think you'll be recoloring an object, make sure it's well lit.

CHANGING BACKGROUNDS

Before

After

*"If you don't like
the background of
a photo, change it!"*

In the previous chapter you learned how to change the color of objects in your photos. But what if it's more than a single object you don't like? What if you want to change the entire background?

As you're finding out, Photoshop Elements makes reality somewhat flexible. If you don't like the background of a photo, change it! All you have to do is paste a new background over the old one—or create a completely new artificial color backdrop.

Paste a New Background into Your Picture

Changing backgrounds seems like a big deal, but the process is a lot easier than you might think. All you need is your original photo, a second photo to serve as the new background, and Photoshop Elements. In your first photo, you select the background area you want to change. Then you select the entire second photo and copy it. Finally, you paste the copied second photo into the selected area of the first photo. The result is your original picture with a new background.

As an example, we'll use this photo of the American flag, proudly waving on a very cloudy day. It's the type of photo you might take while you're on vacation, where you don't have the luxury of waiting until the weather changes. So, you go ahead and shoot against a cloudy backdrop and jump back in the car before it starts to rain. But when you get home and look at your photos, you wish you'd been there on a sunny day. Wouldn't it be great to see the items you've shot against a clear blue sky?

Old Glory on a cloudy day.

Preparation

The preparation for this technique is simple. All you have to do is locate a photo of a bright blue sky. You can shoot a blue sky or be like me and have a few blue-sky pictures just sitting around waiting to be used, like the one in Figure 22.1. In any case, open both photos in

TIP

You want your background photo to be at least as large as the photo you're changing; otherwise, you'll have to stretch the background to fit.

TIP

If the part of the picture you're keeping is smaller and simpler than the background you're changing, you can select that part of the picture instead. You can then invert the selection (so the background is selected) by selecting **Select** > **Inverse**.

Elements—the one you want to change and the one you want to use as the new background—and get ready to go to work.

Execution

The key to switching backgrounds is to select exactly what you need to change. Don't leave any unselected edges, and don't forget any patches of background peeking through trees or windows. You'll paste the new background into this selected area, so you want to make sure everything necessary is selected.

Here's what to do:

1. Click the **Standard Edit** button to enter the Standard Edit mode.

2. In the picture you want to change, use one of the **Marquee**, **Lasso**, or **Magic Wand** tools to select the entire background, as shown in Figure 22.2. If the area you want to replace is of a uniform color, the Magic Wand tool is your best choice; otherwise, the Magnetic Lasso is probably called for.

3. Switch to the photo you want to use as the new background; then select **Select > All**. This selects the entire picture, as shown in Figure 22.3.

4. Still in the new background photo, select **Edit > Copy** to copy the picture to the clipboard.

5. Now it's time to make the swap, so switch back to the picture you want to change; the area you selected in step 1 should still be highlighted.

6. Paste the copied background into the selected area by selecting **Edit > Paste Into**.

The selected area is now replaced by the background you copied in step 3. That's it—not a hard job at all. And the result looks as if you really took the photo on a relatively cloudless day.

Figure 22.1

Open a photo to use as your new background.

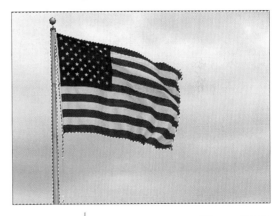

Figure 22.2

Select the background you want to replace.

Figure 22.3

Select the entire picture you want to copy.

Our flag against a brilliant blue sky.

Specific Solutions

TIP

If the new background doesn't completely fill the picture, grab one of the corner handles and stretch it until it fits.

Change More Than the Sky

Sometimes you want to replace more than the sky. For example, here's a picture of a giraffe at a zoo, but the entire background is extremely distracting—way too many trees and posts and fences and such. The giraffe would look a lot nicer against a more natural backdrop, something with mountains and clouds and such.

TIP

For best effect, select a background color that's a darker version of the foreground color, such as light blue and dark blue.

A giraffe against an overly distracting background.

The complicating factor here is that many of the background objects—those same trees and posts and fences—extend into the ground behind the giraffe. We can't just select the sky or stop our selection at a clean horizon; we need to replace part of the ground behind the giraffe, as well.

The solution is to select more than the sky—to pick part of the ground in the background that we want to remove. In this photo, we're going to select everything behind the giraffe down to the bottom border of the chain-link fence, as shown in Figure 22.4. This provides a relatively clean, relatively horizontal break and will look fairly natural when we replace it.

Next, we pick a nice nature landscape, like the photo in Figure 22.5. As described earlier, you select this entire photo (**Select** > **All**) and then copy it to the clipboard (**Edit** > **Copy**).

Now you switch back to the giraffe picture and select **Edit** > **Paste Into**. This copies the second photo into the selected area behind the giraffe, and—voilà!—the giraffe now looks much more at home in the mountains of Montana. (I know, I know, there really aren't any giraffes in Montana—but if there were, this is what it would look like!)

Figure 22.4

Select the entire area behind the giraffe, down to the bottom edge of the fence.

Figure 22.5

Choose a nice nature landscape for the new background.

Our giraffe, with a new mountain background.

Figure 22.6

Set the foreground color.

Figure 22.7

Choose the foreground color for your new background.

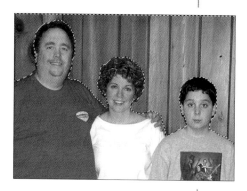

Figure 22.8

Select the background you want to remove.

Create a New Photo Backdrop

Maybe you don't have a spare background sitting around to use with another photo. Maybe you don't want a photographic background at all. Maybe you want the kind of artificially lit backdrop you find in portrait photos.

No problem. Elements lets you create entirely new backdrops and insert them into your photos. This is a perfect technique when you have a group photo, like the one here, that you want to turn into something more resembling a professional portrait. You can create the new backdrop with a combination of filters and layers.

A family photo against an ugly paneled background.

The procedure isn't really that hard. Just make sure you're in the Standard Edit mode; then follow these steps:

1. Before you select anything, you need to determine what color you want the new background to be. Click the **Set Foreground Color** control in the Toolbox (shown in Figure 22.6) to display the Color Picker dialog box (shown in Figure 22.7). Select a color and then click **OK**.

2. Now click the **Set Background Color** control in the Toolbox to display the Color Picker dialog box again; select a background color and click **OK**.

3. Use one of the **Marquee**, **Lasso**, or **Magic Wand** tools to select the entire background, as shown in Figure 22.8.

Figure 22.9

Feather the edge of the selection.

4. A hard edge around the selection makes the new picture look unnatural, so select **Select** > **Feather** to open the Feather Selection dialog box, shown in Figure 22.9. Enter a **Feather Radius** of **5** pixels; then click **OK**.

5. Now you need to delete the current background. With the background selected, select **Edit** > **Clear**. This clears the selected area and replaces it with the background color you selected, as shown in Figure 22.10.

6. Next, make sure the new background has a little texture. Select **Filter** > **Render** > **Clouds** to create a cloud effect, like that in Figure 22.11. (If you want an untextured background, skip this step.)

7. Complete the background by adding a color gradient, which is accomplished via a new fill layer. Create the new layer by selecting **Layer** > **New Fill Layer** > **Gradient**, which displays the New Layer dialog box shown in Figure 22.12. Accept the default name and click **OK**.

8. When the Gradient Fill dialog box appears, as shown in Figure 22.13, pull down the **Gradient** list and select the **Foreground to Transparent** option. (This should be the second option in the top row.)

9. Click **OK** to apply the gradient.

That's it—your picture now has a new color backdrop and looks just like it was shot in a professional portrait studio.

Figure 22.10

Clear the original background.

Figure 22.11

Add clouds to your new background.

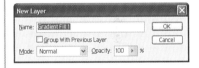

Figure 22.12

Create a new fill layer.

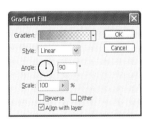

Figure 22.13

Set the gradient fill.

Our family photo with a new color backdrop.

TIP

If you don't like the look of the final result, back up to step 4 and experiment with different foreground and background colors.

How to Shoot Better Backgrounds

Getting the background right in your photos takes careful planning. You can't expect to snap off a quick pic and get professional results. You have to think everything through ahead of time and carefully position your subjects in relation to the available backdrops or scenery. That means rearranging things so extraneous background objects—telephone poles, fences, and so on—aren't visible.

Indoors, position your subjects in front of a blank wall. That might mean removing pictures or other objects to create a clean space. It helps if the wall is a solid color; remember the ugly paneling in our previous example. And have your subjects stand a foot or so in front of the wall to avoid unnecessary shadows and let you get the background just a little out of focus, which helps to draw attention to the subjects in the foreground.

REMOVING UNWANTED OBJECTS (OR PEOPLE!)

Before

After

Having the background interfere with the fore-
ground isn't the worst problem you can have
with a picture. What do you do when you shoot
something—or someone—who you later wish wasn't
there at all?

Although it reeks of the kind of revisionist history you
used to see in old photos of the former Soviet Union's
top brass, you can use Photoshop Elements to totally
remove all traces of selected objects and people from
your pictures. A few clicks of the mouse, and it's like
that thing or person never existed!

"...you can use Photoshop Elements to totally remove all traces of selected objects and people from your pictures"

Crop It Out of the Image

The easiest way to remove something from a picture is to crop it out. That is, you display only that part of the picture that includes the people you want to keep; you cut off the part of the picture that contains the person or object you want to get rid of.

Take this photo of my nephews Alec (left) and Ben (right). Sure, the kids get along fine now, but when they get older…well, you know how brothers sometimes fight. If it gets to the point that Ben doesn't want anything to do with his brother any more, he might need to create a custom photo sans sibling.

Figure 23.1

Select the Crop tool.

Two brothers—and we only want one.

Cropping a person out of a photo is relatively easy, as you first learned in Chapter 3, "Zooming In On the Most Important Part of the Picture." Here's how you do it, from either the Quick Fix or Standard Edit mode:

1. From the Toolbox, select the **Crop** tool, shown in Figure 23.1.

2. Position the cursor at the upper-left corner of where you want the crop to start. Click and hold the mouse button while you draw down and to the right until you've selected the entire region you want to keep in your final picture, as shown in Figure 23.2. When you've made your selection, release the mouse button.

3. Double-click within the selected area to make the crop.

Figure 23.2

Select the part of the picture you want to keep.

There you have it—a new solo photo of Ben, no annoying brother present.

Alec cropped out of the image.

Of course, you've probably already noted the potential issues with this method. First, you end up with a picture that's somewhat smaller than you started with, maybe even with different proportions—both of which could cause problems when printing. Second, you might not be able to crop the person out of the photo; what if they're inside the area you need to keep?

When cropping won't work, it's time to turn to another removal technique. Read on to learn more.

Clone It Away

Try This Instead

The second, more difficult, way to remove someone or something from a picture is to use the Clone Stamp tool. You clone adjacent parts of the background over the thing you want to remove. This can be a long and involved procedure, depending on how big the person you want to remove is and how complicated the background you need to clone is. This method also requires some degree of artistic skill to re-create the background that the person is standing in front of.

Of course, it's easier if the person is standing in front of a plain background, as Alec is in our example. (He's silhouetted against a clear blue sky, thankfully.) If the objectionable person is standing partially

Figure 23.3

Use the Zoom tool to zoom in on the area you want to change.

Figure 23.4

Select the Clone Stamp tool.

in front of another person in your photo, the task might be too complex to pull off.

That said, let's see how you'd go about cloning a person out of a photo. Follow these steps:

1. Click the **Standard Edit** button to enter the Standard Edit mode.

2. From the Toolbox, select the **Zoom** tool (shown in Figure 23.3) and zoom in on the area you want to remove.

3. From the Toolbox, select the **Clone Stamp** tool, shown in Figure 23.4.

4. In the Options bar, shown in Figure 23.5, select an appropriate-size soft-edged brush, and make sure the **Mode** is set to **Normal** and the **Opacity** is set to **100%**.

5. Position your cursor over a spot just beside the edge of the object you want to remove, as shown in Figure 23.6; then press **Alt** (Mac: **Option**) and click the mouse to sample this point.

6. Click and drag the cursor over a small area at the edge of the object you want to remove, as shown in Figure 23.7.

Figure 23.5

Set the options for the Clone Stamp tool.

7. Repeat steps 5 and 6 to clone away more of the selected area. You'll need to resample the area to clone fairly often to keep cloning new background over the object.

This is a difficult process. You often have to guess about what should be behind the person you're removing. You also have to pick your clone points carefully to continue any background pattern. (Again, this is easier if the background is relatively plain.) The result, if you clone slowly and carefully, looks as if the person or thing you removed was never there.

Figure 23.6

Click a spot to clone.

Alec cloned out of the image.

Figure 23.7

Clone over the object you want to remove.

This process becomes more complex when the object you want to remove runs in front of the part of the picture you want to keep. For example, here's a photo of an historic old church, ruined by the all too-modern telephone line running across the top of the picture—in front of the top of the church.

A great picture ruined by the presence of a telephone line across the top.

You can't crop the phone line out or you'll cut off the top of the structure, so your only recourse is to use the Clone Stamp tool to clone it out. In this instance you have to take lots of baby steps, sampling the area directly adjacent to the phone line, then cloning that area onto the phone line one small section at a time, as shown in Figure 22.8. It's very time consuming and tedious, but if you do it right you'll never know the phone line was there.

Figure 23.8

Cloning the phone line out of the picture.

Our church picture, with the phone line cloned out.

How to Shoot Cleaner Pictures

Sometimes you just can't move unwanted objects or people out of the shot; you have to take what you get. When you have the option, however, take it. Wait for strangers to walk out of the shot, or politely ask them to move away; change the angle so that unwanted objects don't appear in the viewfinder. It's a matter of planning and patience. Plan for the least distractions and wait for the shot to clear.

If you know you're going to be shooting something (or someone) you'll later be removing, plan for that, too. That means positioning the person or object away from the main subjects, ideally behind them or to the side. Also try to position the unwanted person against a plain background to make the cloning removal that much easier. Whatever you do, don't position the person in front of something important or in front of something you can't easily replicate with the Clone Stamp tool. It's quite difficult to clone back in something that wasn't there in the first place!

REDUCING GLARE AND FLARE

Before

After

"You often don't know you have a glare or flare problem until after you've taken a picture"

You can take a perfect picture—get the color right, the brightness right, even the people right—but then have it ruined by unexpected reflections. I'm talking about the glare you get in people's glasses and the weird phenomenon known as *lens flare*, which sometimes happens when you shoot into the sun or a bright, direct light.

You often don't know you have a glare or flare problem until after you've taken a picture. Unfortunately, these are very tough problems to fix; sometimes, in fact, you can't fix them at all. Still, there are some things you can try in Photoshop Elements to minimize glare and flare and make the problem a little better, which might be good enough.

Figure 24.1

Select the Zoom area and zoom in on the area to fix.

Figure 24.2

Select the Clone Stamp tool.

Figure 24.3

Set the options for the Clone Stamp tool.

Figure 24.4

Sample a nonglare area to clone.

Figure 24.5

Clone the nonaffected skin over the glare area.

Try This First

Clone Over Glasses Glare

We'll start by looking at glasses glare. This problem is caused by light reflecting off the lens of the glasses. A little glasses glare looks natural; too much glare and you can't see the person's eyes.

The problem with trying to fix glasses glare is that, photographically, that bright white glare totally blows out all the picture information. That is, all you have is the white area of the glare; even if you try to darken it, there's nothing underneath to darken.

That said, if the glare isn't too bad, as with this picture, you can get rid of the glare by cloning an unaffected area over the glare area. This is a viable approach when the glare doesn't totally obscure the person's eyes.

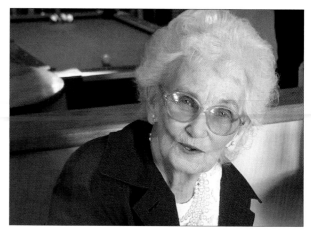

A typical case of reflected light causing glasses glare.

Here's what you need to do:

1. Click the **Standard Edit** button to enter the Standard Edit mode.
2. From the Toolbox, select the **Zoom** tool, as shown in Figure 24.1, and click several times on the eye to zoom in on the affected area.
3. From the Toolbox, select the **Clone Stamp** tool, as shown in Figure 24.2.
4. In the Options bar, shown in Figure 24.3, select a small smooth-edged brush from the **Brushes** menu, make sure the **Mode** is set to **Normal**, and set the **Opacity** to **75%**.
5. Position the cursor on a spot of the face just outside the glare area, as shown in Figure 24.4. Then hold down the **Alt** (Mac: **Option**) key and click the mouse to sample this area.
6. Carefully click over the glare area, as shown in Figure 24.5, painting the sampled area over the glare.
7. You might need to repeat steps 5 and 6 several times, resampling more appropriate areas to clone.

The result looks fairly natural, as you can see here, as long as the glare isn't obscuring any areas that aren't easily cloned.

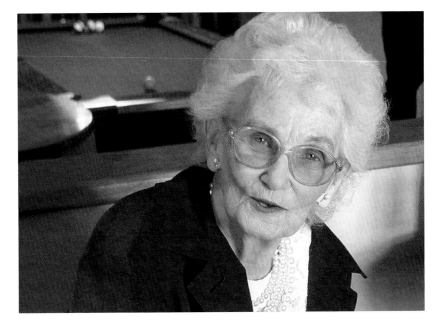

The glare is gone—cloned over.

Copy a Good Eye Over a Glared-Out Eye

Try This Instead

The clone approach is great if you have enough non-glare area to clone and if the glare is over a relatively harmless part of the face. But what if the glare totally obscures one of the subject's eyes?

Almost all the subject's left eye is obscured by glare.

Figure 24.6

Select the Zoom tool and zoom in on the person's eyes.

Figure 24.7

Select the Lasso tool.

Figure 24.8

Feather the edges of the Lasso tool.

Figure 24.9

Select the eye you want to copy.

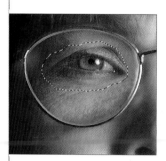

Figure 24.10

Select the Move tool.

Figure 24.11

Move the copy of the eye.

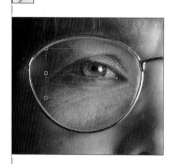

Figure 24.12

The good eye copied over the bad.

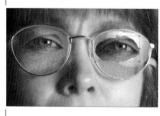

Figure 24.13

Adjust the brightness of the copied eye area.

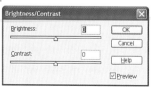

The fix for this problem is somewhat drastic, and not always satisfactory. Essentially, you have to copy the subject's good eye over the glared-out eye.

Here's how it works:

1. Click the **Standard Edit** button to enter the Standard Edit mode.
2. From the Toolbox, select the **Zoom** tool, as shown in Figure 24.6, and click several times on the face to zoom in on the person's eyes.
3. From the Toolbox, select the **Lasso** tool, as shown in Figure 24.7. Right-click (Mac: click and hold) the **Magnetic Lasso** button, and then select **Lasso Tool** from the menu.
4. In the Options bar, shown in Figure 24.8, set **Feather** to **1 pixel**.
5. Use the **Lasso** tool to draw around and select the good eye, as shown in Figure 24.9.
6. Select **Edit > Copy** to copy the selected area.
7. Select **Edit > Paste** to paste a copy of the good eye onto your picture.
8. From the Toolbox, select the **Move** tool, shown in Figure 24.10.
9. The copy of the eye should now be surrounded by anchor handles, as shown in Figure 24.11. Use the **Move** tool to grab the copy of the eye and move it over where the glared-out eye should be, as shown in Figure 24.12.
10. In some cases you might need to brighten or darken the copied area to match the surrounding skin. If so, select **Enhance > Adjust Lighting > Brightness Contrast** to open the Brightness/Contrast dialog box, shown in Figure 24.13. Then adjust the **Brightness** slider as necessary.

11. Now you need to make the new eye blend in with the surrounding skin, smooth out any rough spots around the edges, and deal with any remaining glare around the eye. Before you do this, however, you must merge the copied area (which is on a separate layer) with the rest of the face; do this by selecting **Layer > Flatten Image**.

12. Select the **Clone Stamp** tool from the Toolbox, as shown in Figure 24.14.

13. In the Options bar, shown in Figure 24.15, select a small soft-edged brush from the **Brushes** menu, and make sure the **Mode** is set to **Normal** and the **Opacity** is set to **100%**.

14. Use the **Clone Stamp** tool to clone clean areas over the remaining glare areas and to make the copied skin blend into the surrounding skin area, as shown in Figure 24.16.

This approach works well sometimes, and sometimes it doesn't—all depending on the person's eyes and facial expression. It also might require some trial and error, especially when positioning the copy of the eye.

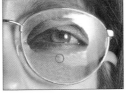

TIP

If all you need to do is blend the copied area into the surrounding area, try using the Healing Brush tool instead of the Clone Stamp tool.

Figure 24.14

Select the Clone Stamp tool.

Figure 24.15

Set the options for the Clone Stamp tool.

Figure 24.16

Clone away the rest of the glare and blend the new eye into the surrounding skin area.

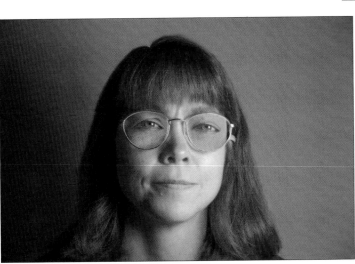

A copy of the right eye copied over the left eye.

CAUTION

You can't use this approach if both the eyes are obscured by glare. You can always try copying eyes from another photo, although it's difficult to make an exact match.

Burn Away Lens Flare

The other problem caused by reflected light is lens flare. Although related to glasses glare, lens flare is a slightly different problem. The flare is a blob of light, typically hexagonal in shape, caused by shooting directly into a bright light source, such as the sun.

For example, this beautiful picture of a Rocky Mountain lake was shot with the camera pointed just below the late afternoon sun. The result is several different lens flares shooting down the center of the picture. How do we get rid of these flares?

NOTE

The hexagonal shape of lens flare reflects the shape of your camera's internal lens aperture blades. The direct light bounces off the glass and metal parts inside your camera, including the aperture blades, and is captured by your camera's image sensor.

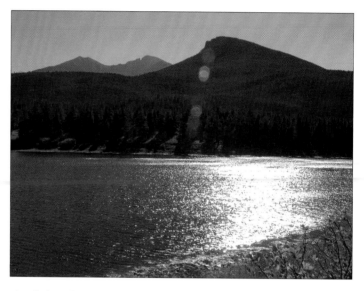

The result of shooting into the sun—lens flare.

Figure 24.17

Select the Zoom tool and zoom in on the area to fix.

Figure 24.18

Select the Burn tool.

I wish there was a simple, effective solution to this problem, but there's not; the best you can do is minimize the effect of these flares. With that in mind, the first thing to try is darkening the flares with the Burn tool, which you can do if the flares aren't too bright—that is, if you can still see detail behind the flared area.

Here's what to try:

1. Click the **Standard Edit** button to enter the Standard Edit mode.

2. From the Toolbox, select the **Zoom** tool, as shown in Figure 24.17, and click the flare to zoom in on that area.

3. From the Toolbox, select the **Burn** tool, as shown in Figure 24.18. Right-click (Mac: click and hold) the **Sponge** tool button and then select **Burn Tool** from the menu.

Figure 24.19

Set the options for the Burn tool.

Figure 24.20

Burn the lens flare until it darkens.

4. In the Options bar, shown in Figure 24.19, select a smallish, soft-edged brush from the **Brushes** menu; then set the **Range** to **Midtones** and the **Exposure** to **50%**.

5. Use the **Burn** tool to paint over the flare, as shown in Figure 24.20, until the flare is as dark as the surrounding area.

As I said, this approach isn't perfect. If the flare isn't too bad, you can probably minimize it to a degree so that it's not totally objectionable. But be careful not to burn the flare *darker* than the surrounding part of the picture!

TIP

If the flare is several different shades of lightness, as many are, burn each part of the flare separately until each part is the same brightness level.

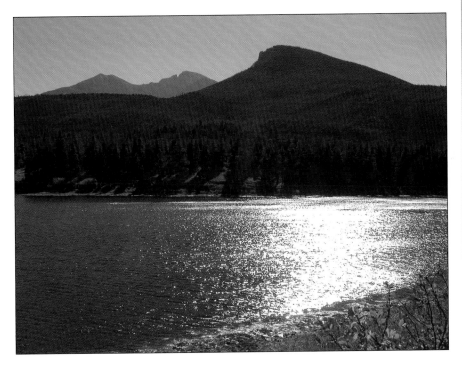

The lens flare minimized.

Clone Over Lens Flare

Try This Instead

If the lens flare is too bright, it totally blows out the picture underneath, as in the lower-left corner of this seaside photo. The result is like a bad case of glasses glare—and the fix is similar. You can use the Clone Stamp tool to clone the surrounding area over the lens flare.

Figure 24.21

Select the Zoom tool and zoom in on the area to fix.

Figure 24.22

Select the Clone Stamp tool.

Figure 24.23

Set the options for the Clone Stamp tool.

Figure 24.24

Sample an area outside the lens flare.

Figure 24.25

Clone the adjacent area over the lens flare.

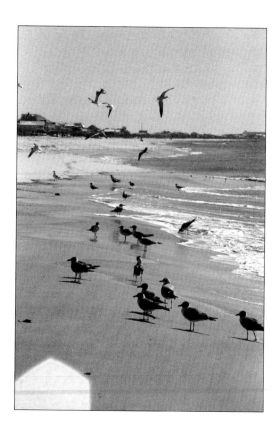

A really bad case of lens flare, totally blowing out any picture detail.

Here's how it works:

1. Click the **Standard Edit** button to enter the Standard Edit mode.
2. From the Toolbox, select the **Zoom** tool, as shown in Figure 24.21, and zoom in on the area around the lens flare.
3. From the Toolbox, select the **Clone Stamp** tool, as shown in Figure 24.22.
4. In the Options bar, shown in Figure 24.23, select a relatively large smooth-edged brush from the **Brushes** menu; then make sure the **Mode** is set to **Normal** and the **Opacity** is set to **100%**.
5. Position the cursor on a spot just outside the lens flare, as shown in Figure 24.24. Then hold down the **Alt** (Mac: **Option**) key and click the mouse to sample this area.
6. Carefully click over area of the lens flare, as shown in Figure 24.25, painting the sampled area over the flare.
7. You might need to repeat steps 5 and 6 several times, resampling more appropriate areas to clone.

As long as the flare is over a relatively simple and unimportant area of the picture, this technique produces more-than-acceptable results.

If the flare is over something more important, however, you might not be able to reconstruct the affected area by cloning—in which case, you might be forced to live with the original lens flare.

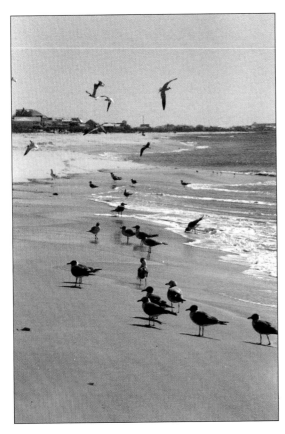

The picture fixed by cloning the surrounding area over the lens flare.

How to Avoid Glare and Flare

Reducing glasses glare is generally as simple as repositioning either the subject or the camera relative to the existing light source. Have the person move his head slightly to the left or right, or even up or down, and you'll see how the glare changes. The more to the side the light is, the less reflection you'll get.

In most instances, lens flare is equally easy to avoid. The main thing is to avoid shooting directly into a bright light—which means no shooting into the sun. If you have to shoot in the direction of the light source, try to block out the light in some way. Use your hand, a hat, a dark piece of paper, or a lens hood to cast a shadow on the front of your camera; this will reduce the flare effect.

Another good idea, if your camera accepts lens filters, is to invest in a polarizing filter. A polarizing filter works like polarized lenses on a pair of sunglasses and helps reduce both lens flare and reflected glare.

RESTORING SCRATCHED AND FADED PRINTS

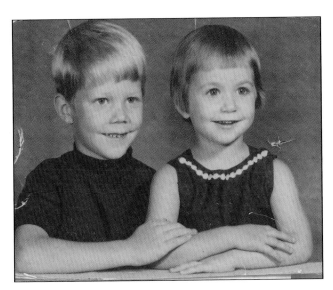

Before

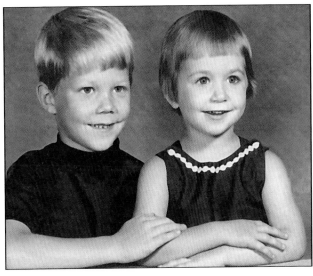

After

"If you want to retouch some old photo prints, this chapter is for you"

This book is primarily about fixing problem pictures taken with a digital camera. But chances are you have some old prints sitting around in a shoebox or photo album, and you might like to add these photos to your digital photo collection. Scanning a print is relatively easy (I provide some scanning tips at the end of the chapter), but you end up with a digital scan of a scratched and faded photo. Wouldn't it be nice to use some simple Photoshop Elements techniques to touch up that old print and make it look as bright and sharp as your new digital photos?

If you want to retouch some old photo prints, this chapter is for you. I walk you through more than half a dozen techniques you can use to make any old print look fresh and new.

Try This First

Crop Any Ragged Edges

Remember the picture of the two 30-something siblings in Chapter 14, "Softening Wrinkles?" Well, here's what they looked like 30+ years ago. Cute, aren't they?

TIP

If you made a sloppy scan of the original print, the result might be a slightly tilted picture. You can fix this by selecting Image > Rotate > Straighten and Crop Image. If this doesn't work, see Chapter 6, "Fixing Tilted Pictures," for more options.

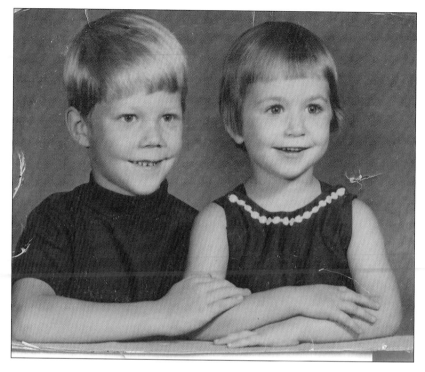

A 30-year-old portrait photo—faded, scratched, and torn.

Figure 25.1

Select the Crop tool.

The photo itself is a typical portrait studio pose of the era. The print has been scanned in at a high resolution (the equivalent of 2 megapixels at 300 pixels per inch), but the picture quality is what you'd expect after 30 years—it's faded, scratched, and torn.

Not to fear. All it takes is a few minutes with Photoshop Elements to fix all these problems.

We'll start with the ragged edges that any print of that age is likely to have. Instead of trying to fix the edges, we'll just trim them off using Elements's Crop tool. You can perform this operation from either the Quick Fix or Standard Edit mode; follow these steps:

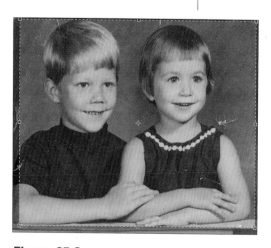

Figure 25.2

The crop area is selected; all the ragged edges outside the selected area will be cropped off.

1. From the Toolbox, select the **Crop** tool, shown in Figure 25.1.

2. Position the cursor at the upper-left corner of where you want the crop to start. Start the crop just inside any torn or ragged edge.

3. Click and hold the mouse button while you draw down and to the right until you've selected the entire region you want to keep in your final picture. Essentially, you should select an area inside the picture's torn or ragged edges.

4. Release the mouse button; the selected area is surrounded by a flashing rectangular border and the area outside the selection dims, as shown in Figure 25.2.

5. Double-click within the selected area to make the crop.

As you can see, this is a quick and easy way to get rid of these corner rips and tears.

NOTE

Learn more about cropping in Chapter 3, "Zooming In on the Most Important Part of the Picture."

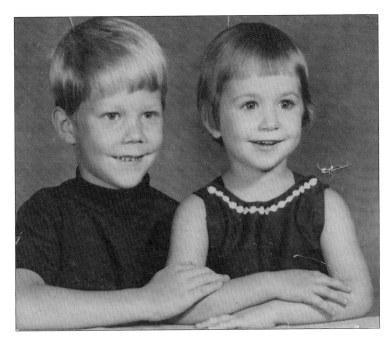

The ragged edges cropped away.

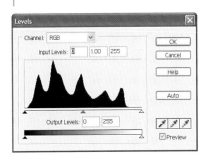

Adjust the Brightness and Contrast

Now we'll go to work on making the picture look brighter and more vivid, which requires correcting the brightness and contrast levels. There are a number of ways to do this, but for most old prints I recommend using a combination of Elements's Levels and Brightness/ Contrast controls, which you can do from either the Quick Fix or Standard Edit mode, like this:

1. Select **Enhance** > **Adjust Lighting** > **Levels** to open the Levels dialog box, shown in Figure 25.3.

2. Start by making the black areas more black. Click the **Set Black Point** button (the leftmost eyedropper) and then click your mouse on a point in your picture that you know should be deep black, as shown in Figure 25.4.

Do This Next

Figure 25.3

Open the Levels dialog box.

Figure 25.4

Set the black point.

Figure 25.5

Set the white point.

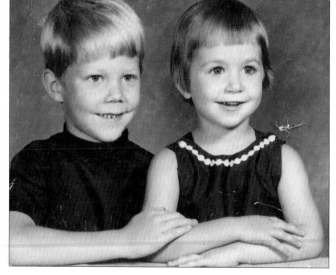

3. Next, make the white areas more white. Click the **Set White Point** button (the rightmost eyedropper); then click your mouse on a point in your picture that you know should be bright white, as shown in Figure 25.5.

4. Now make the overall picture a little lighter or darker, whichever is necessary. Direct your attention to the **Gray Input Levels** slider, which is the middle slider in the middle of the Levels dialog box, right underneath the histogram graph, as shown in Figure 25.6. Drag this slider to the left to lighten the picture or to the right to darken it.

5. When you're satisfied, click the **OK** button to register your changes; Figure 25.7 shows what the picture looks like so far.

6. Now you can adjust the overall brightness and contrast. Select **Enhance** > **Adjust Lighting** > **Brightness/Contrast** to open the Brightness/Contrast control, shown in Figure 25.8.

7. Move the **Brightness** slider to the right to make the picture brighter or to the left to make it darker.

8. Move the **Contrast** slider to the right to add contrast to the picture or to the left for less contrast.

9. Click **OK** when you're done.

The result of using these two controls should be a picture that looks a lot less faded. If you adjusted the controls properly, the picture should be brighter, with more contrast. You might need to repeat steps 2 and 3, clicking in different black and white areas in your picture until you get the results you want.

Figure 25.6

Lighten or darken the picture with the Gray Input Levels slider.

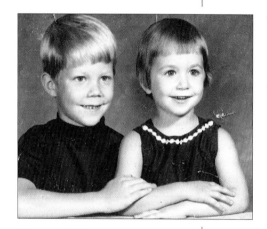

Figure 25.7

Our picture after adjusting the levels.

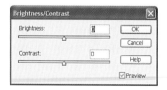

Figure 25.8

Open the Brightness/Contrast control.

A brighter picture, with more contrast—it doesn't look as faded as it did.

Correct the Color Levels

Do This Next

Now let's tackle the picture's color, which is also probably faded a bit. You'll use Elements's Remove Color Cast and Hue/Saturation controls, like this:

1. Click the **Quick Fix** button to enter the Quick Fix mode.

2. We'll start by performing basic color correction to get the hues right. Select **Enhance** > **Adjust Color** > **Remove Color Cast**, which opens the Remove Color Cast dialog box, shown in Figure 25.9.

3. Position your cursor over a spot in your picture that should be a neutral black, white, or gray, as shown in Figure 25.10; then click this spot.

4. The image should change color based on your selection. If you don't like this cast, click a different spot in the photo. When you're satisfied with the color cast, click **OK** to register your changes.

5. If the picture is really faded, you'll probably need to boost the overall color saturation, which you do with the **Saturation** control in the Color section (see Figure 25.11). Move the **Saturation** slider to the right to increase the overall color level or to the left to reduce the saturation.

6. Click **OK** when you're done.

Looks better, doesn't it? If you made the proper adjustments, the colors should be truer and a little brighter—just what the doctor ordered.

Figure 25.9

Open the Remove Color Cast dialog box.

Figure 25.10

Click a neutral black, white, or gray spot.

Figure 25.11

The Quick Fix Color controls.

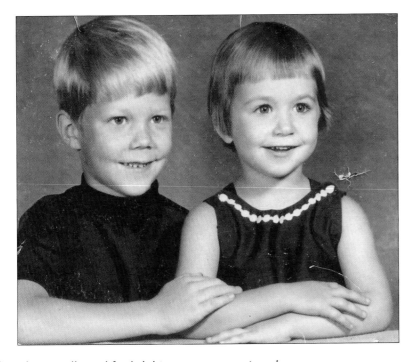

Our picture adjusted for brighter, more accurate colors.

Do This Next

Remove Dust and Scratches

Figure 25.12

Open the Dust & Scratches filter.

Now we need to deal with any minor scratches and dust that have manifested themselves over the years. This begins the repairing part of the restoration process.

You can perform this operation from either the Quick Fix or Standard Edit mode. Here's what you need to do:

1. Select **Filter** > **Noise** > **Dust & Scratches** to open the Dust & Scratches dialog box, shown in Figure 25.12.

2. You want to blur the picture until the dust and scratches disappear. Drag the **Radius** slider to the right to increase the blurring effect or to the left to decrease the effect.

3. Drag the **Threshold** slider to the right until the dust or scratches become noticeable again; then back off slightly.

4. Click **OK** to apply the filter.

This does a good job of getting rid of small picture blemishes; we'll work on bigger glitches in just a minute. But first, we need to correct for the overall blurring that the Dust & Scratches filter introduced, which we do next.

NOTE

Learn more about fixing color problems in Chapter 9, "Fixing Bad Color."

NOTE

Learn more about getting rid of dust and noise in Chapter 11, "Fixing Grainy Pictures."

Dust and scratches blurred away.

Resharpen the Picture

By now, you know that Elements can be used both to blur a picture and to sharpen it. Surprisingly, and to our benefit, after you blur dust and scratches away with the Dust & Scratches filter, resharpening the picture doesn't bring back the dust and scratches—which means you need to do a quick resharpening from the Quick Fix workspace.

Follow these steps:

1. Click the **Quick Fix** button to enter the Quick Fix mode.
2. Go to the **Sharpen** section, shown in Figure 25.13.
3. Move the **Amount** slider to the right until the picture is the desired sharpness.

Do This Next

Figure 25.13

Increase the amount of sharpness in your picture.

NOTE

Learn other picture-sharpening techniques in Chapter 10, "Fixing Soft and Blurry Pictures."

Our picture, with the edges sharpened.

Repair Rips and Tears

Do This Next

Next up on the repair list are any little rips and tears in the picture, as well as any stains or faded spots. We fix this type of damage by cloning good picture over bad using the Clone Stamp tool, like this:

1. Click the **Standard Edit** button to enter the Standard Edit mode.
2. From the Toolbox, select the **Clone Stamp** tool, as shown in Figure 25.14.

Figure 25.14

Select the Clone Stamp tool.

Figure 25.15

Set the options for the Clone Stamp tool.

Figure 25.16

Sample an undamaged area.

Figure 25.17

Clone over the damaged area.

3. In the Options bar, shown in Figure 25.15, select an appropriate-size soft-edged brush. Then make sure the **Mode** is set to **Normal** and the **Opacity** is set to **100%**.

4. Position the cursor over an undamaged area close to the area you want to repair, as shown in Figure 25.16; then press **Alt** (Mac: **Option**) and click the mouse to sample this spot.

5. Move the cursor over the damaged area, as shown in Figure 25.17. Then click and hold the mouse button to clone the sampled area over the damaged area.

6. Repeat steps 4 and 5 as necessary to resample the undamaged area and clone over additional damage.

The picture's looking pretty good, isn't it? You'll probably spend a fair amount of time cloning away damaged areas, so it pays to perfect this technique.

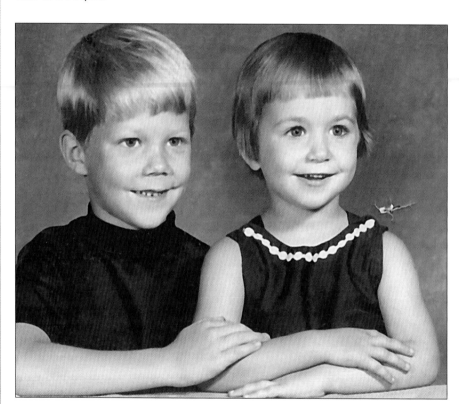

All the big rips and tears cloned away.

Reconstruct Missing Areas

If the damaged area is too large, however, the cloning technique might not do the job. When you're faced with a big chunk of the picture being torn away, you have to take more drastic action to reconstruct the missing part of the picture—which involves copying another part of your picture over the missing area.

Here's what to do:

1. Click the **Standard Edit** button to enter the Standard Edit mode.

2. From the Toolbox, select either the **Rectangular Marquee** or one of the **Lasso** tools, as shown in Figure 25.18.

3. In the Options bar, shown in Figure 25.19, set the **Feather** control to **1 pixel**.

4. Use the selected tool to draw or select an undamaged area of the picture that you can paste over the missing part, as shown in Figure 25.20.

5. Copy this selection by selecting **Edit** > **Copy**.

6. Paste the area you copied back into the picture by selecting **Edit** > **Paste**; the selection seems to disappear.

7. From the Toolbox, select the **Move** tool, as shown in Figure 25.21. The area you just pasted now appears with a flashing border and selection handles, as shown in Figure 25.22.

8. Use the **Move** tool to move this area over the area you're reconstructing, as shown in Figure 25.23.

9. Repeat steps 6–8 to paste and move additional copies of the selected area.

10. Each area you copy occupies its own separate layer within the picture. After you've filled the missing area, you need to combine all these layers into a single layer. Do this by selecting **Layer** > **Flatten Image**.

11. Examine the area you just reconstructed; you might need to make the edges blend into the surrounding picture. Do this by selecting the **Blur** tool from the Toolbox (shown in Figure 25.24).

12. In the Options bar, shown in Figure 25.25, make sure the **Mode** is set to **Normal** and the **Strength** is set to **100%**.

13. Click and drag the **Blur** tool around the edges of the selection, as shown in Figure 25.26, to blur them together.

Figure 25.18

Select either the Rectangular Marquee or Lasso tool.

Figure 25.19

Set the options for the selected tool.

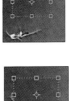

Figure 25.20

Select the area to copy.

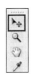

Figure 25.21

Select the Move tool.

Figure 25.22

Getting ready to move the newly pasted area.

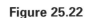

Figure 25.23

Move the selection into the missing part of the picture.

Figure 25.24

Select the Blur tool.

Figure 25.25

Set the options for the Blur tool.

Figure 25.26

Blur the edges of the reconstructed area.

TIP

You also might need to use the Clone Stamp tool to clone around the edges of the pasted selection to better make it fit in with the surrounding area.

That's a lot of work, but it's sometimes necessary. The end result of all these changes? One much better-looking photo, sans the ravages of time.

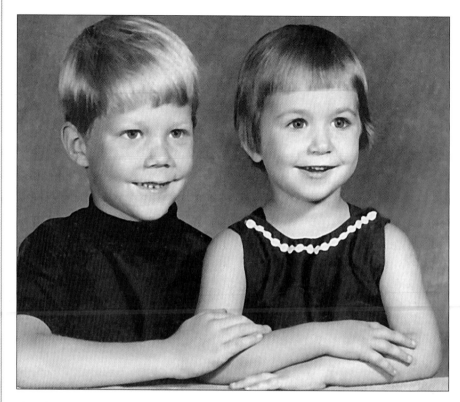

Our final fix—and a totally restored photo.

How to Make a Better Scan

Dealing with a faded old print is bad enough; you don't want to introduce more problems into the picture when you scan it into your computer. Here are some tips for improving your photo scans:

- Scan at the highest possible resolution. That might mean selecting a different resolution from your scanning software's default settings.
- Make sure the scanner glass is clean before you start to scan; a little Windex should do the trick. (You don't want to scan additional dust and smudges into the digital picture!)
- If the print is in a glass frame, remove it from the frame before placing it on the scanner.
- Line up your photo with the side guides on the scanner glass. This prevents scanning a tilted image.

TIP

In Windows XP, you set the scan resolution within the Scanners and Camera Wizard. Click the **Options** button to change the scan resolution.

- If you're scanning a black-and-white photo, scan it as a color photo. This provides more shades of gray to work with when editing in Elements.

And here's one more tip: If you don't want to bother with this whole scanning business, you can have someone else do it for you. Just gather up your old prints or negatives and take them to your local camera or photo processing store. They can do the scanning for you and deliver your newly digitized pictures to you on CD. If you have a lot of prints to scan, the convenience—and professional results—might be worth the cost.

NOTE

Learn other ways to adjust a picture's brightness and contrast in Chapter 7, "Fixing Pictures That Are Too Dark," and Chapter 8, "Fixing Pictures That Are Too Light."

TURNING A BAD COLOR PHOTO INTO A GOOD BLACK-AND-WHITE ONE

Before

After

"That doesn't mean the picture is unsalvageable, however; you can apply a special effect or two and turn that lousy picture into a work of art!"

Even with all the cool techniques available with Photoshop Elements, every now and then you run across a photo that just can't be fixed. That doesn't mean the picture is unsalvageable, however; you can apply a special effect or two and turn that lousy picture into a work of art!

Remove the Color

Most really bad pictures have some combination of problems—too dark or light, bad color, bad focus, and so on. You try to fix one problem, and it just makes everything else worse.

A good example of this sort of unfixable photo is this picture of the publisher's editors and salespeople at Alcatraz prison. (I won't remark on the appropriateness of putting editors inside Alcatraz. Really, I won't.) The available light was minimal; the people weren't standing still; and the result is a picture with bad lighting, bad color, and a fair amount of motion blur. There's even a little red eye, for good measure.

Yuck!

A picture with bad lighting, bad color, and motion blur—a bad-pix hat trick that's almost impossible to fix.

We can try to fix any one of these problems—adjust the brightness and contrast, correct the color, and so on. But as soon as you fix one thing, the other problems just stand out more; the more you work, the worse it gets. And the multiple fixes are extremely time-consuming, besides.

Instead, let's simplify things by completely removing one of the problem elements—the picture's color. Believe it or not, a lot of pictures look a lot better in black and white, problem pictures especially.

Turning a color picture into a black-and-white one is a one-step process. Here's what you do:

1. Select **Enhance > Adjust Color > Remove Color**.

This removes all the color information from the picture, leaving you nothing but blacks, whites, and grays—and a surprisingly okay-looking picture, in spite of its faults.

CAUTION

Elements includes one other way to create a black-and-white picture, by changing the picture's mode from RGB color to grayscale. (You do this by selecting **Image > Mode > Grayscale**.) Do *not* use this method! With a grayscale picture, you can't use many of Elements's tools, controls, and filters. Better to stick with my approach, which creates a color picture with the color information removed.

An okay-looking black-and-white version of our lousy color picture.

Readjust the Picture's Brightness and Contrast Levels

Do This Next

If you really want a good-looking black-and-white picture, however, you'll need to tweak it a little from what you had in the color version. When you remove the color information from a picture, your eye is more sensitive to the brightness and contrast levels; punching up the brightness and contrast can make a big difference in how the picture looks.

Here's what you need to do:

1. Click the **Quick Fix** button to enter the Quick Fix mode.
2. Go to the **Lighting** section, shown in Figure 26.1.
3. Depending on your photo, you might want to make it slightly darker (by moving the **Darken Highlights** slider to the right) or lighter (by moving the **Lighten Shadows** slider to the right).

Figure 26.1

Punch up your black-and-white picture with the Quick Fix Lighting & Contrast controls.

4. Most black-and-white photos benefit by moving the **Midtone Contrast** slider just a tad to the right to increase the contrast level.

As you can see, a little tweaking of the brightness and contrast levels can have a noticeable effect on the picture.

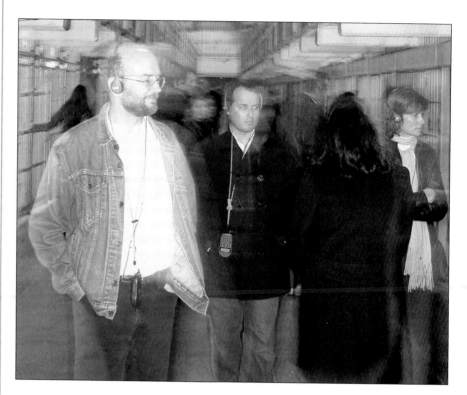

Our black-and-white picture after tweaking the brightness and contrast levels.

Specific Solutions

Hide Blatant Defects by Adding Noise to the Picture

If the picture still doesn't meet your approval, you can try adding one or more artistic effects. Elements has a ton of such effects, all accessible from the Filter menu.

Let me draw your attention to one filter that can turn a so-so picture into an artistic statement. This is the Film Grain filter, which makes it look as if your lousy digital photo was shot on 35mm film.

Here's how to apply the filter, from either the Quick Fix or Standard Edit mode:

1. Select **Filter** > **Artistic** > **Film Grain** to open the Film Grain dialog box, shown in Figure 26.2.

2. Set the **Grain** control to **3**,
 the **Highlight Area** to **1**, and
 the **Intensity** to **1**. (Or just
 play around with the con-
 trols until you achieve an
 effect you like.)

3. Click **OK** to apply the filter.

The result? A slightly grainy,
kind of photo-class artistic effect
that almost looks like you did it
on purpose.

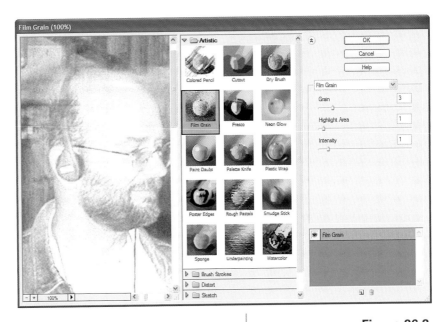

Figure 26.2

*Add an artistic film effect from
the Film Grain dialog box.*

A grainier picture, for dramatic effect.

Create a Sepia-Tone Picture

Of course, the black-and-white effect isn't just for your lousy photos. A lot of photos look good in black and white, especially after you tweak the brightness and contrast.

For example, here's a black-and-white version of the photo of our blushing bride from Chapter 19, "Smoothing Skin Tone and Color." She looks very nice in black and white, suitable for framing.

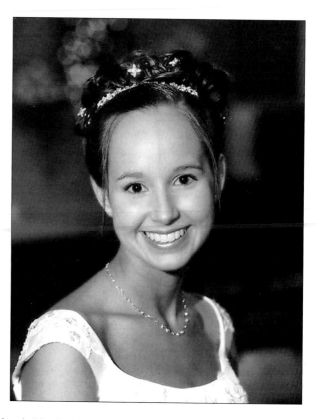

Our blushing bride, in black and white.

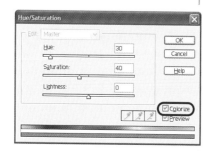

Figure 26.3

Add a sepia tone from the Hue/Saturation dialog box.

You can achieve a slightly different effect by creating not a black-and-white photo, but rather a sepia-tone photo—a picture with a vintage brownish-yellowish cast. It makes your photo look a little old-timey, but with a touch of class.

You start with a black-and-white picture, after removing the color from your original photo. You add the sepia tone by colorizing your picture, which you can do from either the Quick Fix or Standard Edit mode:

1. Select **Enhance** > **Adjust Color** > **Adjust Hue/Saturation** to open the Hue/Saturation dialog box, shown in Figure 26.3.

2. Check the **Colorize** option. (This is important!)

3. Move the **Hue** slider to the left until you reach a good sepia tone; something around **30** is probably right.

4. Move the **Saturation** slider to the left until you achieve a good blend between the color and black and white levels; something around **40** is probably good.

5. Click **OK** to apply the effect.

The result looks almost like a professional portrait!

A sepia-toned bridal picture.

How to Avoid Taking Really Bad Pictures

This concludes not just this chapter, but the book itself. By now, you've learned a lot of quick and easy ways to use Photoshop Elements to fix problem pictures. But wouldn't it be better if you didn't have any problems to fix?

As you get more familiar with your digital camera, you should start taking better pictures, naturally. You'll pay more attention to composition and lighting; you'll learn how to steady the camera when shooting and how to avoid shooting under certain conditions.

But you'll learn a lot faster if you have some help. To that end, I recommend seeking out a local photography club or a basic photography class at a community college. (Ask your local camera store; they'll know whom to call.) The more you shoot, the better you'll get, and it doesn't hurt to have more experienced photographers pointing the way. Photography can be fun and rewarding, even if you only snap the occasional photo.

And if you don't get the shot right the first time, you can fix it later—using the techniques you learned in this book!